CHURCHES OF SUFFOLK

SARAH E. DOIG

AMBERLEY

Dedicated to the memory of my father, Revd Michael Charles Booker (1936–2021)

This edition first published 2023

Amberley Publishing
The Hill, Stroud
Gloucestershire GL5 4EP

www.amberley-books.com

British Library Cataloguing in Publication Data.
A catalogue record for this book is available from the British Library.

ISBN 978 1 3981 1367 1 (print)
ISBN 978 1 3981 1368 8 (ebook)

Typesetting by SJmagic DESIGN SERVICES, India.
Printed in Great Britain.

CONTENTS

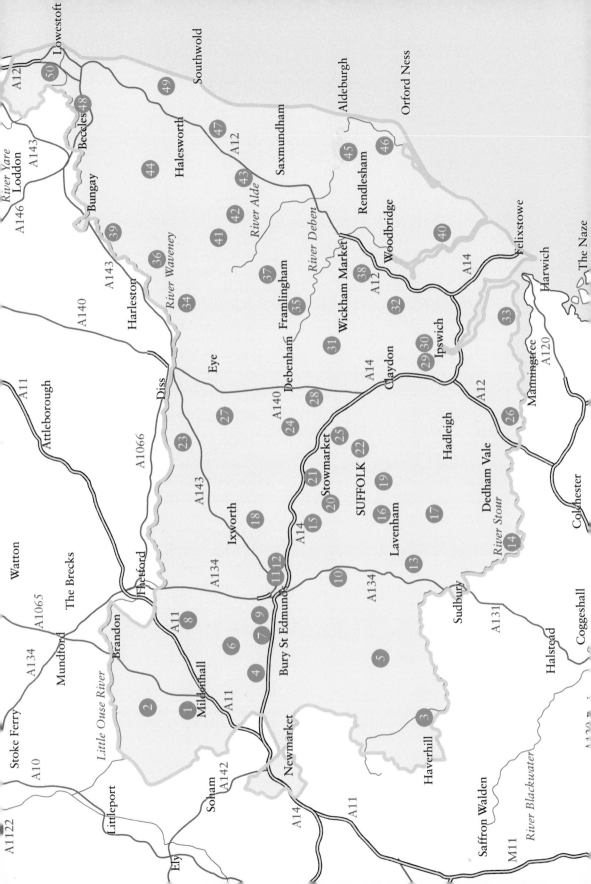

KEY

1. Mildenhall, St Mary
2. Lakenheath, St Mary the Virgin
3. Kedington, St Peter & St Paul
4. Higham, St Stephen
5. Denston, St Nicholas
6. Icklingham, All Saints
7. Little Saxham, St Nicholas
8. Elveden, St Andrew & St Patrick
9. Westley, St Mary
10. Hawstead, All Saints
11. Bury St Edmunds, St Edmundsbury Cathedral
12. Bury St Edmunds, St Mary
13. Long Melford, Holy Trinity
14. Bures, Chapel of St Stephen
15. Hessett, St Ethelbert
16. Preston, St Mary the Virgin
17. Milden, St Peter
18. Stowlangtoft, St George
19. Kettlebaston, St Mary
20. Rattlesden, St Nicholas
21. Harleston, St Augustine of Canterbury
22. Great Bricett, St Mary & St Lawrence
23. Redgrave, St Mary
24. Gipping, Chapel of St Nicholas
25. Badley, St Mary
26. East Bergholt, St Mary the Virgin
27. Thornham Parva, St Mary
28. Crowfield, All Saints
29. Ipswich, St Mary at the Elms
30. Ipswich, Unitarian Meeting House
31. Helmingham, St Mary
32. Culpho, St Botolph
33. Erwarton, St Mary the Virgin
34. Wingfield, St Andrew
35. Brandeston, All Saints
36. Withersdale, St Mary Magdalene
37. Framlingham, St Michael
38. Ufford, St Mary of the Assumption
39. Flixton, St Mary
40. Ramsholt, All Saints
41. Huntingfield, St Mary the Virgin
42. Walpole, Old Chapel
43. Bramfield, St Andrew
44. Westhall, St Andrew
45. Iken, St Botolph
46. Orford, St Bartholomew
47. Blythburgh, Holy Trinity
48. North Cove, St Botolph
49. Covehithe, St Andrew
50. Lowestoft, Our Lady Star of the Sea

INTRODUCTION

I find churches endlessly fascinating. Each one is a time capsule which offers the visitor an insight into the religious life of a community through the centuries. By peeling back the layers of stone, glass and wood inside and out, and by studying how changes in religious practices at a national and local level affected these establishments, a vivid picture emerges of the history of a parish and its people. The Reformation in the sixteenth century and the Puritan movement in the following century both resulted in great structural changes to churches, with rood screens being taken down, and religious icons destroyed. The widespread Victorian restoration movement led to sometimes drastic reconfiguring and fitting out. Church buildings are also a microcosm of the history of architecture: we can see advances in construction techniques and affordability (or not) of materials through time reflected in the walls, ceilings, windows, fixtures and fittings. Many also demonstrate how patrons and incumbents have influenced the church's development.

I must admit to having completely underestimated the challenge I would face to whittle down the many hundreds of Suffolk churches to just fifty. Therefore, I have, by necessity, left out some that you might think merit inclusion, for instance Wenhaston with its incredible doom painting and the fine church at Lavenham financed by wealthy wool merchants. I am sure each one of you will name your own personal favourites that do not feature here, but there is simply no room for them all. What I have tried to do, though, is to present a representative sample of different architectural styles and to choose those churches which have a wide range of features from across the centuries, as well as those which have an interesting story to tell which sheds light on the people that worshipped within its walls. You will see that my selection includes a few buildings that serve religious denominations other than Church of England. I believe it is important not to neglect such gems.

I hope you find the descriptions of my chosen churches both readable and educative. This book does not attempt to replace the excellent guidebooks produced by the individual churches: there is, in any case, far more detail in these than space allows here. Nor does my book seek to provide detailed accounts offered by the standard texts on the subject such as *Suffolk Churches and Their Treasures* by H. Munro Cautley, D. P. Mortlock's *The Guide to Suffolk Churches* and the two Suffolk volumes of Pevsner's *Buildings of England*. Instead, please view this book as a humble attempt to enthuse the reader to explore our county's amazingly rich and varied religious built heritage.

1. BADLEY, ST MARY

Badley sits in probably the most idyllic, magical setting of any church in Suffolk. Deer roam the surrounding farmland and buzzards circle overhead. On entering the churchyard, one might suppose you have been transported back in time several centuries were it not for the recent burials. It is likely that the core of the present-day nave and chancel date from the time of Domesday Book, but the exterior has clearly been updated and altered many times since then. The delightfully unique wooden porch, with its sheep-gate to keep the wildlife out, gives the visitor a taster of the timeless gems to be found inside the church itself.

The interior was passed over by Victorian restorers and so retains many original medieval and Tudor features. That said, the evocative sight of the unstained, sun-bleached fifteenth-century benches and the later box pews, reading desk and octagonal pulpit are a direct result of the intervention of William Dowsing, the famous Puritan who was appointed Commissioner for the Destruction of Monuments of Idolatry and Superstition. Dowsing recorded in his diary that on 5 May 1643 'we brake down 34 superstitious pictures'. The rest of the stained glass not destroyed by Dowsing himself was ordered to be taken down after his visit. The resulting plain glass replacement windows allow the light to flood in, adding to the ethereal nature of the church. Just one piece of medieval glass

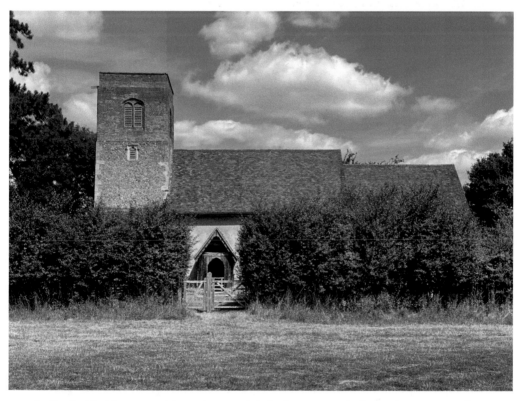

Badley. Inside this unassuming exterior is a church almost untouched over the centuries. (Photo by Sarah Doig)

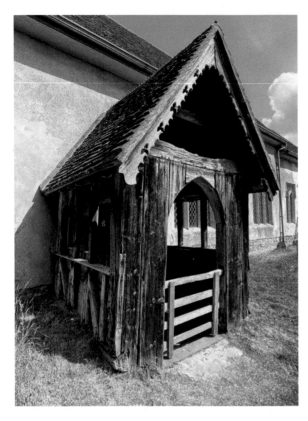

Badley. The inviting south porch
draws the visitor in ... unless
you are an animal! (Photo by
Sarah Doig)

survives which is now set in the north window. It depicts the arms of the de Badele
family who were the local squires.

A notable family who held the Manor of Badley from 1491 until 1707 was
the Poleys and the tiled floor is punctuated by numerous burial slabs for various
family members. The chancel, too, is dominated by two wall monuments to the
Poleys.

In 1926, a programme of repairs was carried out under the auspices of the
Society for the Protection of Ancient Buildings. Then, when the church was
finally declared redundant in 1986, the Churches Conservation Trust assumed
responsibility for Badley church and carried out major restoration works. We owe
these organisations a huge debt of gratitude for ensuring their continued survival.

2. BLYTHBURGH, HOLY TRINITY

Everything about Holy Trinity, Blythburgh is impressive. Perched on high ground
and visible for miles around, it is little surprise that the church is known as the
'Cathedral of the Marshes'. Most of it dates from the fifteenth century when the
existing Augustinian priory was granted permission to rebuild its parish church
and only the fourteenth-century tower of the former structure was retained.
The market town and the priory were already in decline when construction
started, but luckily various wealthy locals left hefty bequests in their wills which
financed the building of the chancel and some of the windows, in particular.

The exterior boasts some fine flushwork – the use of flat knapped flints to form panelled patterns – particularly on the porch and east end. Binoculars are needed to spot the wonderful stone figures on pedestals on the south and east sides which range from Christ and the Virgin Mary to a collared bear and a fox with a goose in its mouth.

The crowning glory of the whitewashed interior of Blythburgh is its original painted roof resplendent with pairs of beautifully carved angels. Each one holds the shield of one of the original benefactors of the rebuilt church. Despite the now serene atmosphere, this heavenly host witnessed a visitation from the devil himself. According to a contemporary pamphlet written and published by Revd Abraham Fleming, during morning service on 4 August 1577, lightning, which accompanied the appearance of a huge, ferocious black dog, 'cleft the door, and returning to the steeple, rent the timber, brake the chimes' and a man and a boy were found 'starke dead'. This devil-incarnate also left his trademark in the form of deep, black claw marks on the north door of the church (which can still be seen today).

Walking around the inside of the church reveals numerous delightful medieval features, such as the series of restored poppyhead bench ends, and the fragments of medieval glass set in the clear glass windows. Other original features include

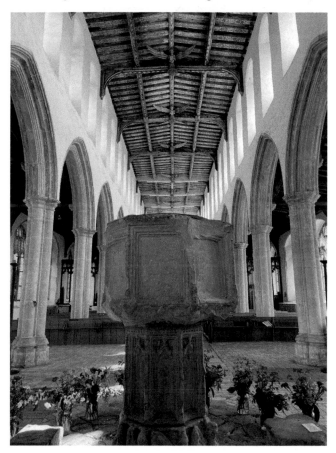

Blythburgh. The famous angels watch over those being baptised. (Photo by Sarah Doig)

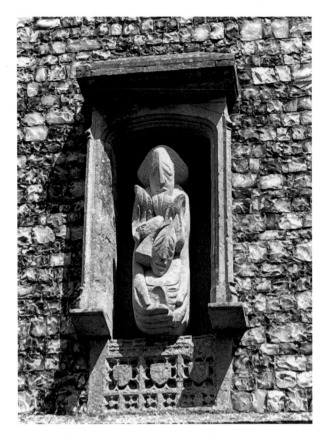

Blythburgh. A modern
sculpture above the door of
the south porch. A first-floor
priest's room lies behind it.
(Photo by Sarah Doig)

the large Seven Sacrament font, badly defaced by the iconoclast William Dowsing, which is surrounded by rare stone stools for priest and sponsors, and a wooden alms box by the small north door. One of my personal favourites from more modern times is the exquisite stained-glass memorial to a churchwarden who died in the 1980s. Blythburgh is undoubtedly a church worthy of a long visit to appreciate its many, many delights.

3. BRAMFIELD, ST ANDREW

St Andrew's in Bramfield rightly jostles for pole position as the prettiest church in Suffolk. The tasteful yellow wash on the exterior walls gleams in the sunlight and the thatched roof is picture-perfect. To top that is the fine, detached round tower which is Norman in origin – the only one of its kind to have been built as a freestanding structure. The main fabric of the nave and chancel is entirely fourteenth century, having replaced an older church on the same site.

The sparsely furnished nave has two particularly interesting features. On the north wall there are traces of a fourteenth- or fifteenth-century wall painting with a cross at its centre and four angels holding chalices. There are also the four exquisite Victorian windows – two on each wall of the nave – fashioned using light green decorative glass. Each window depicts a different religious symbol, namely, the olive, the lily, the rose and the passionflower.

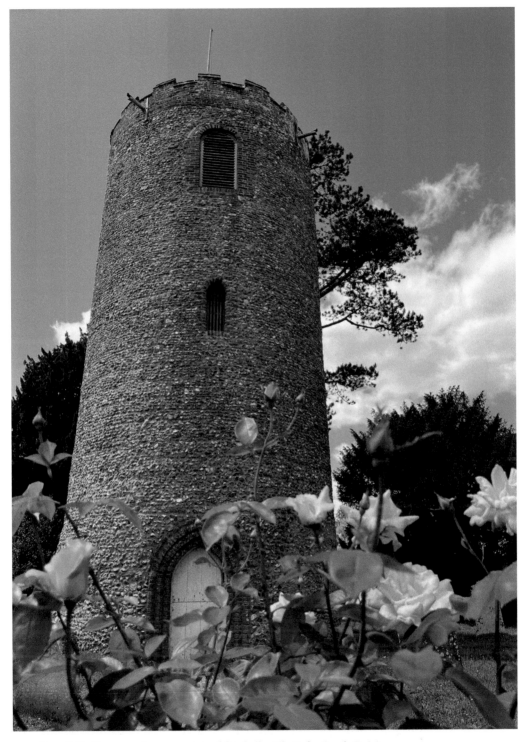

Bramfield. The tower houses a ring of five bells. (Photo by Sarah Doig)

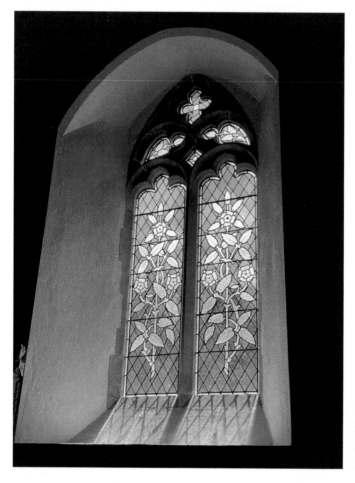

Bramfield. Roses are featured in this Victorian nave window. (Photo by Sarah Doig)

The medieval rood screen separating the nave and chancel is a sight to behold, beautifully carved and still bearing the original colours of mainly red, blue and gold, which must have been magnificently vivid when the screen was first erected. The lower part of the screen features paintings of Mary Magdalene and the four New Testament gospel saints.

In contrast with the nave, the chancel is crammed full of goodies. There is a large, dark grey, twentieth-century stone reredos which is considered a fine piece of craftmanship. Also dominating this part of the church is a wall monument and tomb chest, dating from the 1620s, to Arthur Coke and his wife, Elizabeth. The effigy of Mrs Coke, who holds a baby, is by the renowned sculptor Nicholas Stone. The stars of the show, however, are the numerous ledger slabs which almost completely cover the chancel floor. Commemorating various members of the Nelson, Rabett and Applewhaite families, the inscriptions are well worth a read as they reveal some wonderful details about the illnesses which led to their deaths, including Edward Nelson (d. 1726) who was 'eaten away by consumption of the lung' and Bridgett Applewhaite who died in 1737 of an apoplectic fit just before she could 'run the risk of a second marriage-bed'!

4. BRANDESTON, ALL SAINTS

For a church with a chancel once described as ruinous, All Saints, Brandeston, with its clean, white-rendered walls and red-tiled roof, now presents a neat face to the world, thanks to the Victorian restorers. The church sits alongside Brandeston Hall, once home to the Revett lords of the manor and now Framlingham College Junior School. The Revetts' influence inside the church is to be seen at almost every turn and includes the attractive communion rail given by John Revett in 1711, the elaborate wall monument to John Revett (d. 1671), as well as the nineteenth-century reading desk and box stall, reusing former chancel panelling installed by John Revett in 1745.

The whole church is light and airy with whitewashed walls and large, mostly clear glass windows. However, many of the window edges contain earlier delicate coloured glass of foliage and flowers. More substantial sixteenth-century glass survivals include figures of a blue-robed monk and a kneeling abbot. These were installed by the then vicar, John de Bury.

A modern wall plaque commemorates another of Brandeston's vicars who ended his days at the end of a rope. John Lowes was accused by the self-styled Witchfinder General, Matthew Hopkins, of being in league with the devil. Lowes was put on trial by swimming and because he floated rather than sank, was deemed a witch, and subsequently hanged.

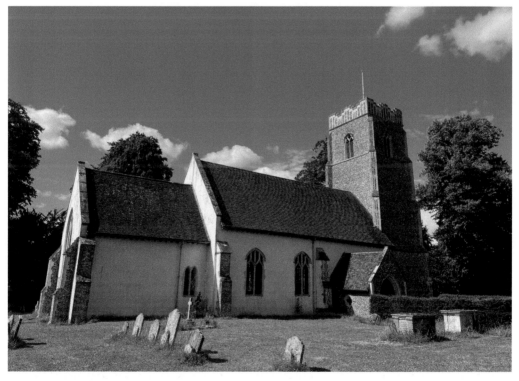

Brandeston. The north porch is a Victorian addition, replacing a now demolished one on the south side. (Photo by Sarah Doig)

Brandeston. The rood stairs are still visible although the screen has long since disappeared. (Photo by Sarah Doig)

Visitors with a musical bent will be interested in the rare eighteenth-century organ and the board which records the almost three-hour seven peals of bells performed by six men in 1749/50.

The medieval bench ends, both in nave and chancel, are delightful. There is a man astride an unidentifiable beast, another figure sits reading a book and, as well as other animals, there is a rather curious rabbit-cum-duck – make your own mind up!

5. BURES, CHAPEL OF ST STEPHEN

On turning the final corner on the trek along a stony track, the visitor is rewarded with a fairy-tale sight: a thatched chapel first consecrated by the Archbishop of Canterbury on St Stephen's Day in 1218 on the exact spot where it is said that Edmund the Martyr was crowned on Christmas Day in 855. Over the centuries, the building has fallen into disuse and disrepair. It was divided into cottages and then used as a barn until it was completely restored by Isabel Badcock and her brother-in-law, Will Probert, in the 1930s. The dreamy nature of the hilltop setting, overlooking the Bures dragon – a twenty-first-century creation on the facing hillside – adds to the sense of magic.

The interior of this single-oblong chapel is dominated by several tomb chests with life-size effigies. In fact, the congregation at one of the chapel's twice-yearly services must feel they are intruding on a private family occasion such is the dramatic placement of two of the monuments right in the middle of the space!

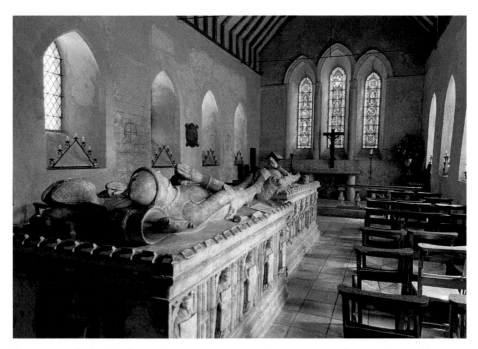

Bures, Chapel of St Stephen. The rather quirky interior where worshippers rub shoulders with the Earls of Oxford. (Photo by Sarah Doig)

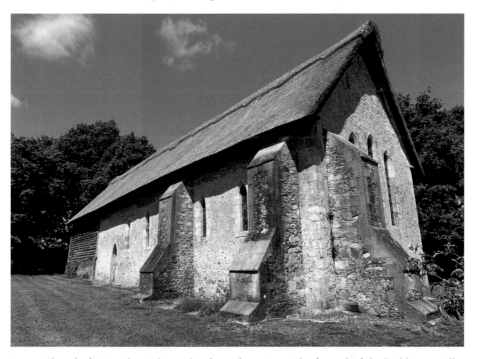

Bures, Chapel of St Stephen. The timber-framed section at the far end of the building is still a barn. (Photo by Sarah Doig)

These memorials are to Thomas de Vere, 8th Earl of Oxford (d. 1371), and to Richard de Vere, 11th Earl of Oxford (d. 1417) and his second wife, Alice. One of Richard's ancestors, Robert de Vere (d. 1296), lurks in the north-west corner of the chapel and an even earlier forebear, Aubrey de Vere (d. 1141), is present in the form of the lower half of his coffin lid. All these de Vere memorials resided, at one time, in Earls Colne priory which the family had acquired after the Dissolution.

The small lancet windows of St Stephen's contain medieval fragments of glass and are complemented masterfully by the predominantly blue, stained glass east window constructed in 1934. Several original consecration crosses have been uncovered as have some of the earlier 'mock masonry' painting on the walls. This is a real gem and well worth a visit to the furthest southern reaches of the county.

6. BURY ST EDMUNDS, ST EDMUNDSBURY CATHEDRAL

In 1914 when a new diocese was created, the parish church of St James became the Cathedral Church of St Edmundsbury and Ipswich. Despite this overnight elevation in status, this former abbey church had always been a jewel in Suffolk's crown. Since the eleventh century, the church has been subjected to rebuilding and redesign by some of the finest architects and craftsmen in the country. In the 1500s, a new nave was built to the design of the famous master mason John Wastell, and the celebrated architect Sir George Gilbert Scott was responsible for the Victorian chancel and reroofing of the nave.

Apart from the Sanctus bell, there are no bells inside the main body of the cathedral. Instead, the impressive Norman Tower, built in the mid-twelfth century as the main entrance to the Benedictine abbey, has served as a bell tower for St James since the Middle Ages.

The riot of colour that awaits the visitor inside the cathedral is the culmination of the vision and determination of Stephen Dykes Bower, the cathedral's architect in the mid-twentieth century. During his watch, the west porch, cloisters, a new quire, two chapels and the crossing were all added. On his death, Dykes Bower left £2 million for the completion of the building project, and a public appeal raised further funds to which the Millennium Commission granted matching funding. In 2010, the scheme was finally complete with the unveiling of the magnificent vaulted ceiling for the Millennium Tower.

In stark contrast to the splendour of the rest of the building, the simplicity and serenity of the Chapel of Transfiguration are equally awe-inspiring. On the wall behind the simple stone altar is a sculpture entitled *Christ Crucified* by Elizabeth Frink onto which light floods through the clear glass windows.

Stained-glass enthusiasts will spot some early sixteenth-century Flemish fragments, as well as plenty of fine Victorian windows. Even though I spent my childhood waiting patiently (or impatiently!) at the west end for my cue to process down the nave as a chorister, I never spotted, in one of these stained-glass windows, the trumpeting elephant and giraffes happily munching leaves from the top branches behind the lion (and lioness?) being tamed, perhaps, by an angel!

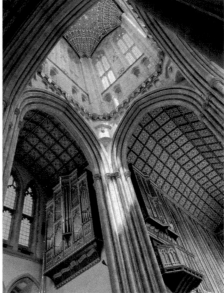

Above left: Bury St Edmunds, St Edmundsbury Cathedral. The pure simplicity of the Chapel of Transfiguration. (Photo by Sarah Doig)

Above right: Bury St Edmunds, St Edmundsbury Cathedral. A glimpse of its crowning glory: the exuberant ceiling of the Millennium Tower. (Photo by Sarah Doig)

Bury St Edmunds. The remains of the thirteenth-century charnel house in the Great Churchyard. (Photo by Sarah Doig)

7. Bury St Edmunds, St Mary

The parish church of St Mary, Bury St Edmunds lies across the Great Churchyard from the cathedral. St Mary's, too, used to sit within the boundary of the abbey before the Dissolution and was chosen as the final resting place for Henry VIII's sister, Mary Tudor. She had been buried, with much pomp and ceremony, in 1533 in the Benedictine abbey but just six years later, after the king closed the institution, he gave permission for Mary to be reburied in this church. However, this now rather modest tomb is far from the only treasure within its walls. Visitors flock from far and wide to view the magnificent hammerbeam roof with its eleven pairs of life-size angels, arranged in a procession in honour of the Assumption of the Blessed Virgin Mary.

The other major draw is, in fact, the cadaver tomb of the benefactor who paid for the angel roof. John Baret, who died in 1467, had an effigy of himself as a decaying corpse made during his lifetime and on his death, he left money for the chantry chapel with its unique ceiling in which he now rests.

The church has benefitted from other wealthy donors over the centuries, most notably one of the town's fifteenth-century aldermen, Jankyn Smith, who gave money for what is now known as the Royal Anglian Regiment chapel. One of

Bury St Edmunds, St Mary. Above the chancel arch lies the Edmund window, based on a design of a medieval pilgrim's badge. (Photo by Sarah Doig)

Bury St Edmunds, St Mary.
Memorials line the interior
walls of the tower. (Photo by
Sarah Doig)

Smith's contemporaries, John Notyngham, bequeathed money for the construction
of an elaborate north porch.

One of the oldest parts of the church is the chancel. Way above the visitor's
head sit numerous wooden, carved bosses, all brightly coloured and depicting all
manner of men, flora and fauna.

Despite all these fine medieval features, no glass from this period survives.
The enormous west window dates from the 1850s and was paid for by local
landowners as a thanksgiving for a bumper harvest. The stunning square window
above the chancel arch depicts the martyrdom of St Edmund. Look out, too, for
the Victorian, individually designed poppyhead pew ends.

8. COVEHITHE, ST ANDREW

The dramatic sight of this once great church serving the small coastal village
of Covehithe simply takes your breath away. It is now, in fact, a church within
a church; the 'new' church is a simple thatched affair which is dwarfed by its
predecessor, albeit now in ruins, and the still-intact fourteenth-century tower
looms large. The original church must have been magnificent; the roofline can
still be made out on the tower and the scale of the entire building is shown by
the surviving shell. The opulence of the exterior decoration is also still evident,
demonstrated by the beautiful flushwork chequerboards and elegant arches.

Covehithe. A once magnificent traceried window frames the present church building. (Photo by Sarah Doig)

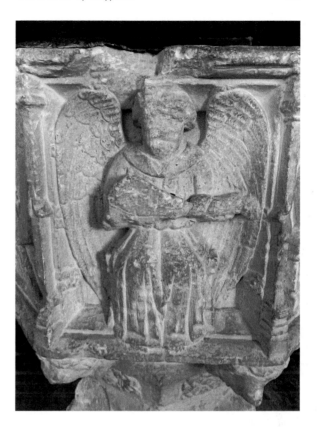

Covehithe. One of four angel
musicians depicted on the font.
(Photo by Sarah Doig)

It is possible that Puritan destroyer of icons William Dowsing did the church
authorities in Covehithe a favour. During his visit on 6 April 1643, he 'brake down
200 pictures ... There was [sic] many inscriptions of jesus [sic], in capital letters,
on the roof the church, and cherubims with crosses on their breasts; and a cross
in the chancel.' By the seventeenth century, the parish could no longer afford the
upkeep of this oversized church and so the churchwardens got permission to partly
dismantle it and to build the much smaller replacement, using material from the
older structure. The two officials must have been proud of their accomplishments
because their names are immortalised in two stones set into the inside of the new
chancel walls.

Luckily, not all the former church's furnishings were done away with.
The fifteenth-century font, the pulpit and a few poppyhead bench-ends provide
some interest in the otherwise spartan, whitewashed interior.

9. CROWFIELD, ALL SAINTS

The church at Crowfield delights the eye from every angle, inside and out. When
you emerge into the light from the heavily wooded path, the extremely attractive
half-timbered, tastefully colour-washed chancel greets you. Perched on its gable
end is a twenty-first-century replacement cross in natural wood, a careful replica
of the previous one. So, this is a church not only steeped in history but beloved by
its present-day parishioners.

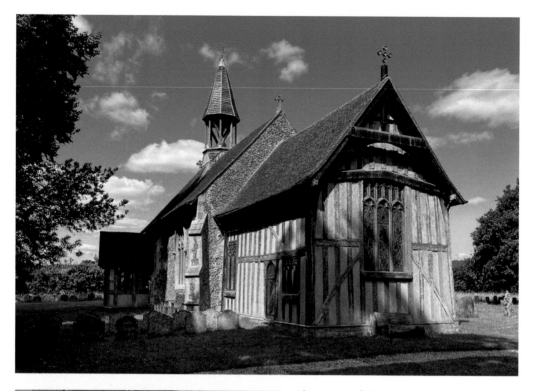

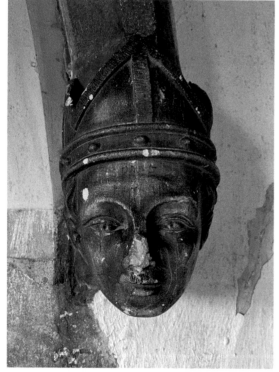

Above: Crowfield. The timber-framed windows on the north and south side of the chancel are original. (Photo by Sarah Doig)

Left: Crowfield. A friendly face in the porch greets visitors. (Photo by Sarah Doig)

The core of the medieval church we see today retains its Norman footprint of nave and chancel. The perfectly formed timber porch was added in the fifteenth century and the bell turret appeared sometime later. This latter feature has been altered over the centuries and enhances the charm of the building.

Many might be surprised by the interior of All Saints, perhaps because one expects it to be one of those which escaped heavy updating. It didn't. However, the result of an almost complete restoration project in 1862 resulted in what the *Ipswich Journal* described as 'undoubtedly the most costly and choice piece of church restoration that has come to our notice for many years and the chapel is a perfect model of chaste and elaborate design and finish'. Whether or not these Victorian furnishings and restylings are to your taste, it is clear that no expense was spared, and the church exudes a homely, lived-in air. The medieval hammerbeam roof has been given angels and standing figures, and each of the poppyhead ends of the nave pews has a different foliage or fruit design.

Almost every inch of Crowfield's small, partly wood-panelled chancel is taken up by tasteful stained glass, brass memorials and a funerary hatchment to past lords of the manor, and wall plaques on which are painted the Lord's Prayer, the Creed and the Ten Commandments. After such amazing 'busy-ness', I must confess it is quite a relief to step foot once again into the tranquil and lush churchyard.

10. CULPHO, ST BOTOLPH

The nave of the church of St Botolph reminds me of a 1980s barn conversion with its exposed, neat brickwork, heritage paintwork, restored and revarnished beams. That is, of course, in a good way. It is very light thanks to the clear glass windows and the mix of old and updated features works perfectly. The pews have long since disappeared, to be replaced by wooden chairs. Whilst some churches would have ditched their Decalogue, Creed and Lord's Prayer boards long ago, Culpho's canvas ones are re-sited, prominently on the nave walls. Other older elements in this fourteenth-century core include the medieval font with quatrefoil bowl panels with foliage designs beneath, the piscina where the priest would have washed his hands and the communion vessels used at one of the long since disappeared nave altars, and a more recent wall-mounted alms box.

The small, narrow, heavily restored chancel is also light despite the Victorian dark wood roof. A piscina next to the high altar, like that in the nave, sits next to a lowered windowsill which serves as a sedilia – a seat for the priests. On the wall is a plaque made from glass tiles giving thanks to God for the village's deliverance from the enemy in the First World War. In fact, Culpho is one of just two so-called 'Thankful Villages' in Suffolk not to have lost a single resident in either of the two world wars.

Talking of 1980s restoration, the tower was renovated then. It is one of several porch towers in the county, quite a few of which are in this part of East Suffolk. It would once have been much taller but is now capped with a red-tiled pyramid roof. The inside and outside of the tower walls bear graffiti from centuries past, including pilgrim crosses, and if you look closely around the exterior, you can make out a medieval scratch or mass dial, which would have served not only as a clock but also would fix the times of the services.

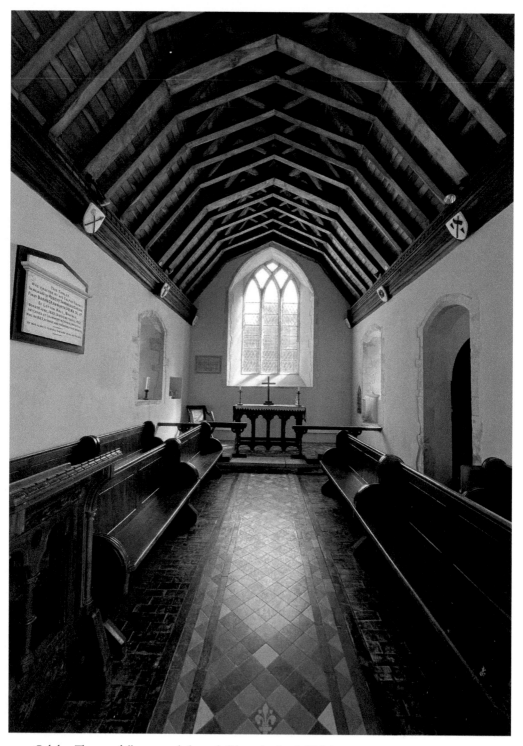

Culpho. The tastefully restored chancel. (Photo by Sarah Doig)

11. DENSTON, ST NICHOLAS

I wholeheartedly agree with some of the great authorities on Suffolk churches that St Nicholas is magnificent. The perfectly formed body of the fifteenth-century Perpendicular church, attached to a modest tower built a century earlier, is a delight to view and it is no surprise, given the large number and height of the windows, that the inside has a light and airy feel. The design of the interior, with its unbroken length of nave and chancel with supporting aisles and clerestory, makes it feel more like a cathedral.

I always feel like a child in a sweet shop being let loose inside this church. There is so much to explore at every turn, and one must be alert not to miss the finer details such as the fan vaulting in the porch, the marvellous collection of strange animals carved in the deep cornicing between the walls and the roof, and the wooden gates to the south chapel which are carved to look like ironwork.

One of my very favourite features in St Nicholas is the woodwork. The oak benches in the nave are original and feature a wide range of animals, both mythical and real, including an abundance of rabbits, a unicorn, fox and goose, a cockatrice and a rather brave attempt by the fifteenth-century carver of an elephant. In the chancel stalls, there are four misericords – hinged, tip-up seats which allowed the priests some support to rest their weary legs during the long services. The choirstalls, like the pews in the nave, have animals on the finials and

Denston. The impressive south frontage. (Photo by Sarah Doig)

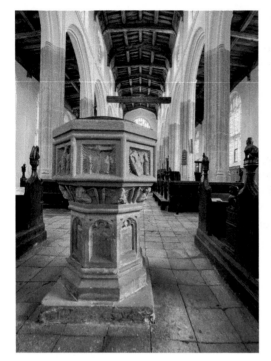
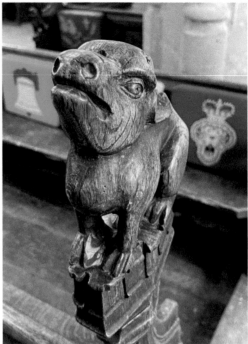

Above left: Denston. Lofty arches and large windows in the nave allow light to flood in. (Photo by Sarah Doig)

Above right: Denston. One of the many delightful bench ends. (Photo by Sarah Doig)

there is a ledge running along the bottom which served as a bench seat for the singing boys.

The founder of the chantry chapel next to the church, John Denston, can still be found probably twice – once in life and once in death – in the chancel. The east window contains jumbled fragments of medieval glass including a figure at prayer which is believed to be Denston and on the north side of the sanctuary is a rather gruesome double cadaver table tomb. Here man and wife lie in their partially open body bags.

Monuments and memorials to other squires and landed families are all around, including heraldic brasses of Henry and Margaret Everard, a large altar tomb and hatchments commemorating the Robinson family, as well as the tabard, helmet and sword of John Robinson (d. 1704).

12. East Bergholt, St Mary the Virgin
It is a temporary structure standing in St Mary's churchyard that many visitors come to see. For a building not meant to last very long, it has weathered the ravages of time very well indeed. This bell cage was constructed in 1531 after funds had run out to build a church tower. The latter has never been finished and so the heaviest peal of five bells in the world are still housed and rung in this timber and tile 'shed'.

I am not sure I agree with Pevsner and Mortlock who say that the church itself is impressive and picturesque, but this is down to personal taste. Nevertheless, it certainly has much of interest both inside and out in this hotchpotch of styles, ranging from the fourteenth to the nineteenth centuries. The base of the planned tower survives and shows that it was meant to have a processional way beneath.

This is Constable country and so, if you have time to search the gravestones, you can find William Lott who lived in the house at Flatford immortalised in the painter's most famous work, *The Hay Wain*. John Constable was baptised in the church, his parents are buried in a family tomb here and there is a memorial to John's wife, Maria, in the chancel. Constable painted St Mary's a number of times, including one of the south porches with its priest's room above.

The interior was almost completely refurbished in the 1860s and '70s in line with the beliefs of the Oxford Movement. The result is a rather gloomy church even on a sunny day, which would be even darker were it not for the delightful, pastel-tinted clerestory windows.

There are some lovely original medieval features dotted around the church. An Easter Sepulchre has been uncovered in the chancel wall and in the north aisle, there is the parish chest dating from 1400. Several memorials are also worth pausing for, including the one to John Mattison in the north aisle, who was for 'Eleven years the Beloved School Master of this Town, and then Unfortunately

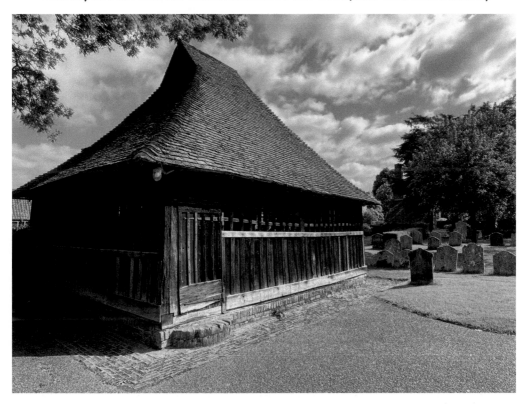

East Bergholt. The great tenor bell in the cage weighs over a ton. (Photo by Sarah Doig)

Shott the 23rd November 1723, Aged 38'. The Latin couplet underneath translates as 'He profited and pleased, mixed business with pleasure, to his pupils a terror and a delight.'

13. ELVEDEN, ST ANDREW & ST PATRICK

It takes a while to work out this church. It has benefitted from such generous patronage over the years that the medieval church of St Andrew is almost unrecognisable. This building, with its origins in the twelfth century, has now become the south aisle and chapel of the present-day parish church in Elveden. It is dwarfed by the new nave and chancel and by an impressive bell tower which, although attached to the church by a dreamy cloister, sits within the grounds of the neighbouring Elveden estate.

Until 1869, the nave of St Andrew's had a thatched roof, but this was replaced by a slate one by Elveden Hall's most famous residents, the deposed Maharajah of the Sikh Empire, Duleep Singh. He also paid for the renewal of the nave windows and new benches to replace the old box pews. The Maharajah also paid for a new

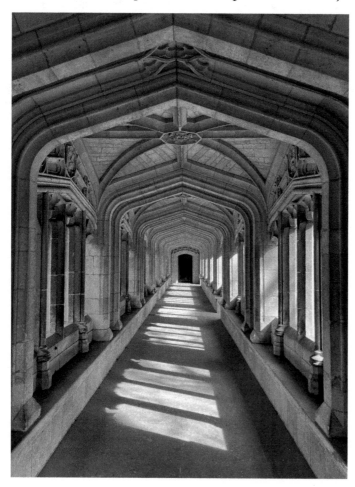

Elveden. This cloister and the second tower were constructed in 1922 and dedicated to the memory of the 1st Viscountess Iveagh. (Photo by Sarah Doig)

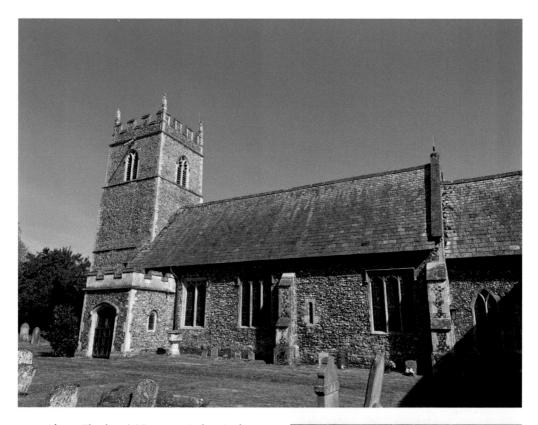

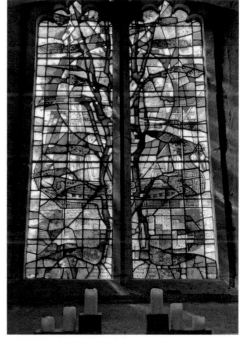

Above: Elveden. A Norman window in the south aisle helps date the original part of the church. (Photo by Sarah Doig)

Right: Elveden. A window designed by Lawrence Lee and installed in 1977. It depicts aspects of the life of the 2nd Earl of Iveagh. (Photo by Sarah Doig)

alabaster font. However, it was his successor on the estate, Edward Cecil Guinness, Viscount Iveagh (later the first Earl of Iveagh), who, in the early twentieth century, totally transformed the church by building a new nave and chancel to the north dedicated to St Patrick, as well as the cloister and second tower.

The Iveagh Arts and Crafts restoration and enlargement has resulted in a very busy interior. The new nave has a double-hammerbeam roof in true medieval style adorned with angels, some playing musical instruments such as the lute and harp. The arcade of arches linking the old with the new parts of the church has sculpted faces, foliage and flora in abundance. The chancel's clergy and choir stalls have meticulously carved figures of saints, and the focal point of the sanctuary is the magnificent alabaster reredos featuring numerous apostles, saints and ancient Christian monarchs of East Anglia.

This rather dark church is cheered up no end by the stained glass, many of which are memorial windows to residents of Elveden Hall and the wider village; it was a community that did not forget their war dead, in particular.

14. Erwarton, St Mary the Virgin

The church door creaks open, and I am immediately struck by the thought that I may have interrupted a family party. The revellers have, however, quickly returned to their tombs and are as still as stone. Even the lions on the octagonal fifteenth-century font look as though they have been caught mid-merrymaking. However, far from giving out forbidding vibes, the church seems to welcome the visitor with open arms. The remarkable light flooding into St Mary's is that which you get only on the Suffolk coast and Erwarton, towards the tip of the Shotley peninsula, benefits from being almost entirely surrounded by water. The interior is sparsely but tastefully furnished, the Victorian fittings, which include an elegant pulpit, sitting comfortably alongside the medieval memorials.

Although mainly comprising clear glass, colour adorns some of the windows. One of the most interesting of these stained-glass panels commemorates the life of Frank Cole (d. 1990) who was a historic wallpaper designer. The window was inspired by a nineteenth-century hand woodblock-printed wallpaper designed by Pugin for the Houses of Parliament.

The various effigies on the tomb chests date from the thirteenth and fourteenth centuries, the oldest of which is Sir Bartholomew D'Avilliers who died in 1287 and who looks extremely relaxed with his legs crossed as if he is just taking a nap. The double tomb depicts Sir Bartholomew Bacon and his wife, Anne, and Bacon's daughter lies on the opposite side of the nave.

The Parker family of nearby Erwarton Hall is also represented in the church and the rather pompous wall memorial to Sir Philip Parker claims an ancestry which included Anne Boleyn, the second wife of Henry VIII. During the 1838 restoration of the chancel, it is said that a heart-shaped leaden box was discovered walled up in an alcove. Eyewitnesses told of the moment when the box was opened: inside was only a little black dust. The box was reburied beneath the organ with a small plaque marking the spot which relates the legend that this was the heart of Anne Boleyn herself who had, during her visits to Erwarton, expressed a wish for her heart to be buried here.

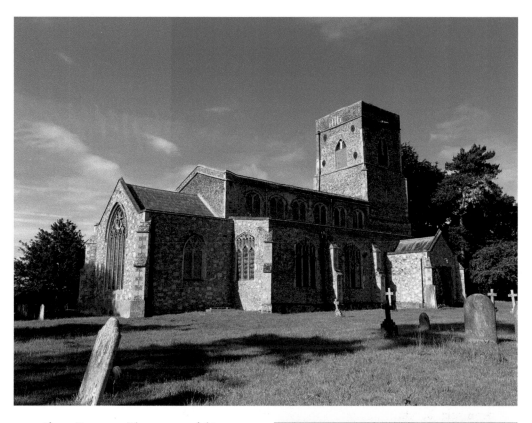

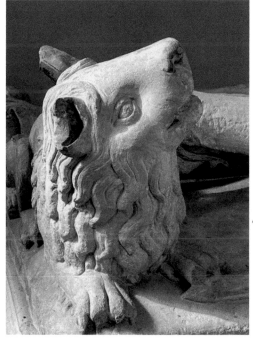

Above: Erwarton. The parapet of this Perpendicular west tower was renewed in red brick after it was damaged by lightning in 1837. (Photo by Sarah Doig)

Right: Erwarton. Sir Bartholomew Bacon rests his feet on a lion. (Photo by Sarah Doig)

15. FLIXTON, ST MARY

This is a church which can be easily overlooked, not least because it is well hidden from the road by dense foliage. St Mary's has two particularly outstanding features worthy of a visit.

The church tower at Flixton is of a unique design in Suffolk. In fact, there is only one other like it in the country: at Sompting in Sussex where this unusual shape – reminiscent of churches of the Rhineland in Germany – is Saxon. By contrast, Flixton's tower was built in 1856, replacing an earlier one that had

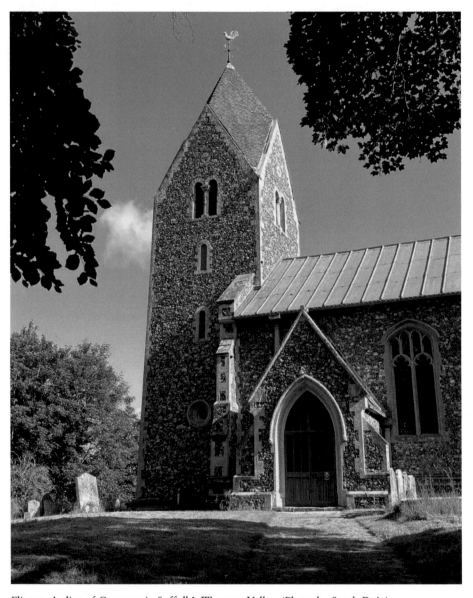

Flixton. A slice of Germany in Suffolk's Waveney Valley. (Photo by Sarah Doig)

collapsed some twenty years before. The architect responsible for the new structure, Anthony Salvin, claimed that the original tower had been of a similar design, although an early nineteenth-century sketch shows a rather more typical square tower. The new one is certainly striking and clearly no expense was spared by the Adair family of Flixton Hall who financed it, as well as having the rest of the church almost completely reconstructed in English Perpendicular style, adding a north aisle. The very dark neo-Norman chancel replaced an older, derelict structure. Adair family memorials litter the walls, and their predecessors as lords of the manor, the Tasburghs, also remain in the church in the form of memorial slabs and brasses set into the floor. The rather curious, chunky font is a Victorian attempt to recreate a Norman model.

Inside, the visitor's eye is immediately drawn to the light emanating from the north-west corner. Here we are greeted by a remarkable octagonal, vaulted chapel. The centrepiece of this later addition is a life-size effigy of Lady Theodosia Adair, who died in 1871. She is depicted at prayer and was created by Henry Bell of Norfolk. The sculpture was commissioned by Lady Adair's widower, Sir Robert Shafto Adair, although it was his brother, who inherited the baronetcy, that completed the chapel in which the Theodosia Adair statue resides.

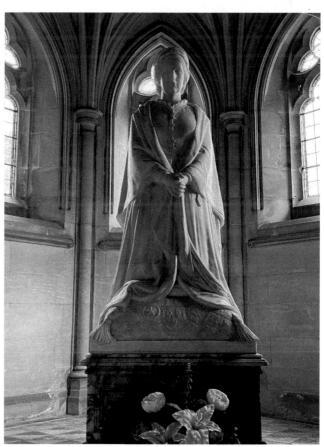

Flixton. This elegant chapel was completed in 1902. (Photo by Sarah Doig)

16. Framlingham, St Michael

I challenge you to name a parish church in the whole country, other than St Michael's, that houses such a prominent memorial to an illegitimate son of a king. Had it not been for his untimely death at the age of seventeen, Henry Fitzroy, Duke of Richmond and Somerset, may well have acceded to the throne after his father, Henry VIII, and British history would have run a completely different course. Fitzroy's elaborate altar tomb sits in the full-width chancel alongside arguably more spectacular examples commemorating the Howard Dukes of Norfolk. These were all originally destined to rest in Thetford Priory but, following the Dissolution, were found a home in Framlingham where the chancel was built specially to house these memorials.

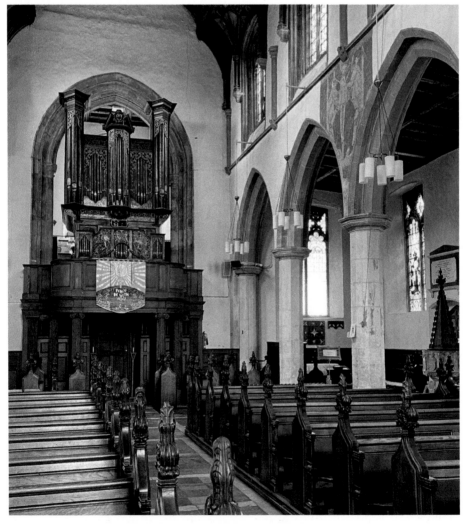

Framlingham. The Thomas Thamar organ and the fragment of medieval wall painting visible on the north nave wall. (Photo by Sarah Doig)

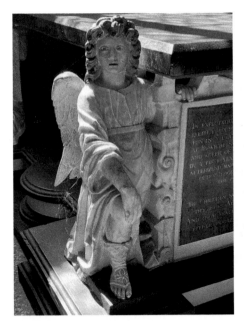

Above left: Framlingham. One of four angels who guard the tomb of Sir Robert Hitcham (d. 1636), a major local benefactor. (Photo by Sarah Doig)

Above right: Framlingham. A figure on the tomb of Henry Fitzroy overlooks the Glory reredos, painted at the beginning of the seventeenth century. (Photo by Sarah Doig)

It is difficult to know where to start when describing the numerous treasures within this magnificent church, which sits alongside the marketplace and just down the road from Framlingham's historic castle. Some aspects of the building we see today date from the twelfth century, the nave arches from the 1300s, and the stunning roof with its delicate tracery and fan vaulting, the high clerestory windows and tower from the fifteenth century. Two key fourteenth-century features are the font with its oak cover, both with faint traces of their original paint, and the wall painting between two of the nave arches. Although only part of the original full painting survives, we can see that it portrays God holding the crucified Christ.

Organists from all over the world are drawn to St Michael's to see and to play on the seventeenth-century Thomas Thamar organ. It was originally built for Pembroke College, Cambridge, but when a new chapel was built at the college, the organ was given to Framlingham. It is a rare survival from the pre-Commonwealth era when many organs were destroyed. In fact, such was the rejoicing in Framlingham when Charles II was restored to the throne that a superb royal coat of arms was commissioned in 1661. It hangs in the south aisle of the church.

By the late nineteenth century, the fabric of St Michael's was in a very poor state. An appeal was launched which led to the complete restoration and some reconfiguration of the building. This was at the height of the Arts and Crafts movement and examples of this influence can be seen in the use of stencilling on the chancel walls and some of the replacement windows in the south aisle.

17. Gipping, Chapel of St Nicholas

'Beware of rabbit holes' is the simple warning affixed to the gate of St Nicholas' Chapel in Gipping. It sits rather incongruously alongside notices of forthcoming services and a summer fête. So, feeling like a modern-day Alice in Wonderland, I enter the churchyard which, although scattered with evidence of burrowing mammals, is devoid of burials. This is because it has never been a parish church. Instead, it was built, in the 1480s, as a private chapel for Sir James Tyrell, who lived in his now demolished manor house immediately to the east. It became a free chapel in 1743 and has remained as such ever since, cared for by a group of trustees.

The tower, constructed over a century after the main body of the chapel, is best overlooked. Luckily, this is easy to do as the visitor's eye is immediately drawn to the beautiful, intricate flushwork flints which cover the whole of the rest of the building. The Tyrell 'knot', their family emblem, appears frequently on the stonework on the buttresses and the tall, three-light windows in both nave and chancel add to the sense of drama. Around to the north, a small annex was added soon after the original building work, and this has a curious dummy bay window.

The inside of the chapel is simply furnished with cream coloured, painted box pews and almost nothing on the walls. Here, though, it is the fabulous east window that takes centre stage – literally. In the 1930s, this window was reset with many delightful medieval fragments of stained glass.

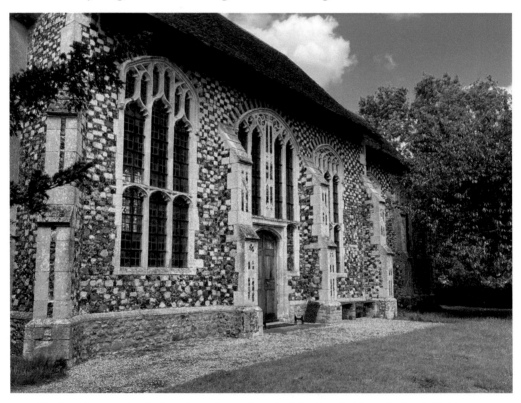

Gipping. The stunning flushwork on the north wall of the chapel. (Photo by Sarah Doig)

18. GREAT BRICETT, ST MARY & ST LAWRENCE

Because of several original architectural features, St Mary & St Lawrence sets ecclesiastical historians' hearts racing. From the outside, the church is certainly intriguing. This parish church started life as an Augustinian priory dedicated to St Leonard in 1110. As an institution affiliated with a French, rather than English, religious house, Great Bricett was suppressed by Henry VI a century earlier than other monasteries and abbeys across England. Today, the building consists solely of a single width and height nave and chancel with a tie-beam roof, which was once part of a larger monastery complex. There are blocked-in doorways and windows along its length, as well as surviving ones, ranging in style from Norman to Tudor.

The fine Norman doorway is not in its original place, but further along to the west and is sheltered by a tasteful Victorian porch. You can easily spot the door's original, now bricked-in, location which has an impressive eleventh-century stone sundial above it. This dial was used to indicate the times of the services, having scratched on it four lines radiating from the centre where the gnomon would once have cast a shadow on the face of the dial. Stepping foot inside the church, it is the equally fine twelfth-century font that catches the eye. The detail on each of its four sides is slightly different.

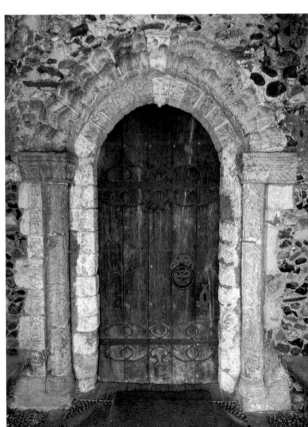

Great Bricett. An inscription carved into the stonework includes the word LEONARDUS. (Photo by Sarah Doig)

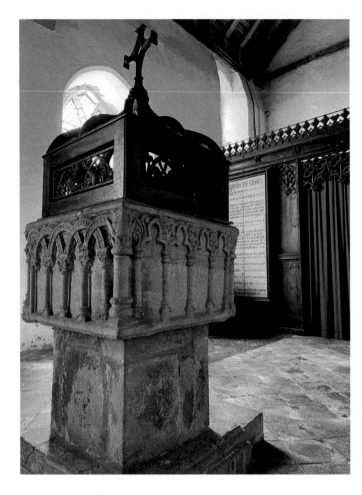

Great Bricett. Behind
the screen at the west
end is a blocked-up
arch, suggesting that
a tower was once
planned or even built.
(Photo by Sarah Doig)

The medieval era is also represented in the church: look for the two wonderful stone heads and the stained-glass fragments depicting the four Evangelists in one of the south-facing windows. These were once in the upper tracery of the east window, which is a Victorian replacement. This too, though, has altered since its installation. The stained glass in the lower part was destroyed during the Second World War and plain glass was substituted. Moving forward even further in time, a small lancet window in the south wall now holds glass produced in the mid-1970s which depicts the two saints to whom the church is now dedicated.

19. HARLESTON, ST AUGUSTINE OF CANTERBURY

The village of Harleston, which sits a few miles to the west of Stowmarket, boasts one of the prettiest churches in Suffolk and, possibly, in the country. Its remote position, surrounded by arable fields, provides an extremely tranquil setting for those laid to rest in the churchyard. Amongst these burials is a row of uncommon cast-iron grave markers, and beyond their simplicity lies a sad tale of the death of five siblings from the Armstrong family who were between six months and twelve years of age when they died of diphtheria in 1891.

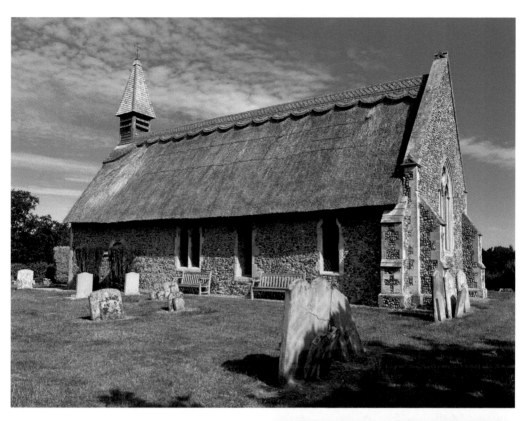

Above: Harleston. The walls and thatched roof form an unbroken line from the west end of the nave to the east end of the chancel. (Photo by Sarah Doig)

Right: Harleston. One of four weeping angels, probably designed by H. Munro Cautley. (Photo by Sarah Doig)

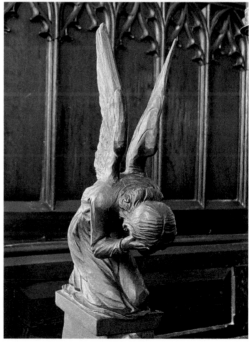

This thatched church of St Augustine of Canterbury – one of only two in the country with this dedication – is Norman in origin. The south doorway and a bricked-in north doorway date from this time, as does the nave. The chancel dates from the fourteenth century when, probably, the rood screen was also installed. The font, too, dates from the 1300s. The church has no tower although it has a nineteenth-century bell turret.

The surprise comes when entering the chancel. It has been completely refurbished with panelling, altar rail and stalls in dark wood. Although the whole church was restored, inside and out, in the 1860s, it is highly likely that these furnishings date from the 1930s when the great Suffolk church historian H. Munro Cautley was the diocesan architect. The crowning glory here are the four kneeling angels, two of which – according to the churchwarden who showed me round – keep getting knocked and damaged by those processing in from the nave.

20. HAWSTEAD, ALL SAINTS

As you walk up the path towards All Saints, the impressive early sixteenth-century tower, with its full-height stair turret, greets you, looming large over the churchyard. The body of the church is neat and well-cared for, but the several blocked-in windows in the chancel, which dates from around 1300, make it look, from the outside at least, a rather poor relation to the rest of the building. You don't have to look for very long to find the shields of the main manorial families to have poured money into the church over the centuries. The base of the tower, with some intricate flushwork, bears a frieze of shields of the Drury family, and the porch windows bear further shields of the Drurys, together with the Cullums and Metcalfes.

Inside, too, there are reminders of the lords of the manor at almost every turn: they cover the floors and walls, as well as having left their mark on the church furnishings such as the rare pre-Reformation pulpit. There are numerous funerary hatchments to the noble families dotted around the place. The large, late fifteenth-century nave and south porch still retain some earlier features, like the Norman door. The compact font dates from the 1200s and has, at some time in the past, been moved into the base of the tower. It bears traces of the iron fastenings which were once used to lock the cover to the bowl to prevent the holy water from being used for witchcraft. The original woodwork, including the angel hammerbeam roof and the rood screen, has been much restored and updated, and the pews are mid-nineteenth century.

Whereas Metcalfe memorials cover the nave walls, it is the Cullums and the Drurys who dominate the busy chancel. There are too many to mention here and are therefore deserving of a visit to explore them. The earliest is a wonderful effigy of a cross-legged knight, thought to be Sir Eustace Fitz-Eustace (d. 1271).

Unless you know it is there, it is easy to miss the real rarity in Hawstead. This is the surviving wooden housing for the sacring bell atop the rood screen. It is believed that the bell itself, too, is a pre-Reformation survivor. It was rung at the climax of the Mass for the benefit of those inside the church (as opposed to the Sanctus bell which was rung at the same time to be heard by those in the neighbourhood who were unable to attend the service).

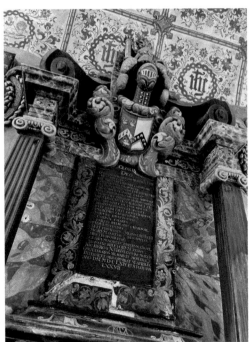

Above left: Hawstead. Medieval graffiti on the chancel walls suggests that bored choirboys perhaps found ways to entertain themselves. (Photo by Sarah Doig)

Above right: Hawstead. The flamboyant Italianate memorial to Sir Thomas Cullum (d. 1664) in the chancel. (Photo by Sarah Doig)

Right: Hawstead. One of the sixteenth-century allegorical creatures adorning the Victorian pews. (Photo by Sarah Doig)

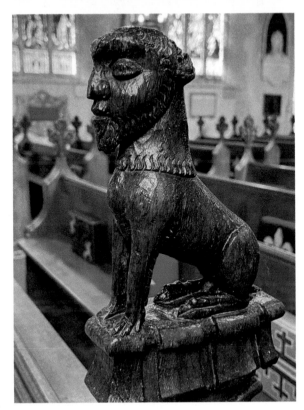

21. HELMINGHAM, ST MARY

Everything about St Mary, Helmingham screams money and a glance over to the west, through the hedges and trees, will tell you where this wealth originated. Helmingham Hall and the church are Tollemache territory, and a visitor is reminded of this constantly, both inside and out. The church was built in the late

Helmingham. Thomas Aldrich of North Lopham was contracted to build the tower for 10 shillings a foot at a rate of 6 feet a year. (Photo by Sarah Doig)

fifteenth and early sixteenth centuries and the exterior of the church has plenty of tidy flint and flushwork which is topped by an equally neat, red-tiled roof. There are no aisles, nor is there a clerestory. When a Tollemache burial vault was added underneath the chancel in the late 1700s, this part of the church was entirely rebuilt. An impressive stonework inscription at the south base of the tower translates as 'The Virgin Mother, branch of Jesse's stem, ascends to heaven', referring to the church's dedication.

When you step inside St Mary's, it is not necessarily the plethora of Tollemache memorials that catch the eye. Instead, it is the large biblical texts painted in red and black around each doorway, window and arch, as well as on every available space on the walls. These were the work of John Charles Ryle who was Rector of Helmingham in the mid-nineteenth century. These, and the rather plain, plastered roof make for an austere atmosphere. It is dark, even on a sunny day. The beautifully carved, carefully restored fifteenth-century font glows in the gloom. If you had not spotted it from the outside (although I doubt whether anyone would have missed it), a dormer window in the south side of the roof not only lets some much-needed additional light into the nave, but also accommodates the top of the supersized monument erected in 1615. On the top tier is the Lionel Tollemache who had died ten years previously. Below him are his father, grandfather and great-grandfather, all confusingly called Lionel although each deserving of a different little rhyming inscription.

One rather more understated but elegant, black marble plaque sits above the south door of the chancel. It is to Catherine, wife of one of the Lionel Tollemaches, who died in 1620. Part of the inscription on this memorial reads 'while she lived for her pietie towards God, pitie towards the poore, & charitie in releeving (through her skill & singular experience in chyrurgerie), the sick & sore wounded, was beloved & honoured of all, as now missed & lamented in her death'. It bears witness to an extraordinary member of this noble family who not only ran the household but also practised both medicine and surgery which were, at this time, normally the preserve of men.

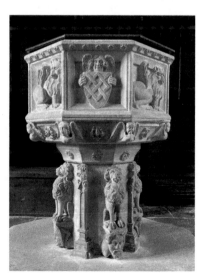

Helmingham. The renewed or partially renewed octagonal font is hard to date. It bears the Tollemache arms. (Photo by Sarah Doig)

22. HESSETT, ST ETHELBERT

I must confess never to have stopped in the village of Hessett before I decided to visit the church and I suspect even St Ethelbert's might be overlooked unless you have read about the many treasures it contains. That said, it is a handsome church dating from the fourteenth century whose roof was originally thatched. Then in the late 1400s, the local squire, John Bacon, financed its enlargement, employing the master mason at the abbey at nearby Bury St Edmunds to design the works. Bacon's initials appear on the shields near the top of the castellated tower and on the buttresses of the south porch. He is not the only wealthy local to have poured money into the church. An inscription which runs around part of the north of the building tells us that John Hoo (who died in 1492) and his wife paid for the building of the north chapel, the heightening of the vestry (by adding a first floor) and the battlements for the whole church.

Not all Hessett's treasures still reside in the church. When the iron-bound parish chest – which does still sit in St Ethelbert's – was opened by Oliver Cromwell's men, a rare pyx cloth (a veil used to cover the vessel containing the blessed sacrament) and a burse (a receptacle for the communion bread), both dating from the Middle Ages, were found inside. These are now in the British Museum.

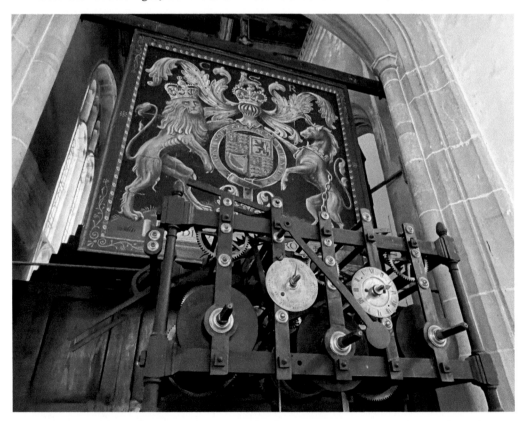

Hessett. The royal arms of Charles II, which once adorned the chancel arch, sit above the mechanism of the nineteenth-century church clock. (Photo by Sarah Doig)

There is, however, plenty more to see in the church today. The font at the back of the nave, said to date from 1451, is designed for the total immersion of infants. The intricately carved, fifteenth-century rood screen has been repainted in what may have been the original colours – predominantly blue and red with gilding. The chancel, too, offers up some interesting gems such as the medieval 'return' stalls with their delightful carvings.

Above all, though, the church is best known for its wealth of medieval stained glass and for its wall paintings. By far the most impressive of these paintings is that of the seven deadly sins which sit above a so-called 'Christ of the Trades', depicting tasks which were deemed ungodly to undertake on the Holy Day. St Barbara and her tower, St Christopher, and St Michael with his weighing scales also appear on the walls of the north and south aisles.

23. HIGHAM, ST STEPHEN

What a delight it must have been for the residents of the newly created ecclesiastical parish of Higham – a hamlet of Gazeley until 1894 – to commission a new church in which to worship. The church authorities had £3,600 at their disposal and so they chose the very best. Sir George Gilbert Scott, the celebrated High Victorian Gothic architect, designed and built this church, which was completed in 1861. The flint exterior has bands and dressing of limestone and is constructed in the

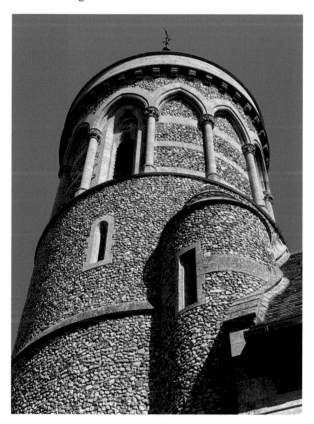

Higham. The clean, neat round tower designed by Sir George Gilbert Scott. (Photo by Sarah Doig)

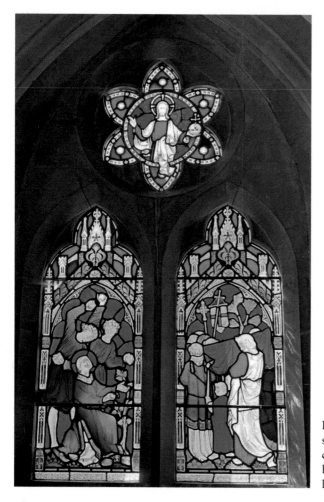

Higham. One of the stained-glass windows in the chancel depicts the death and burial of St Stephen. (Photo by Sarah Doig)

Early English style of the thirteenth century. When completed, St Stephen was the newest of Suffolk's thirty-eight round-towered churches.

Gilbert Scott rather unusually appears to have designed or commissioned almost everything inside the church, and although the heavy stone font, pulpit and corbels (the stone roof supports in the shape of animals, birds, foliage and even human heads) are not to everyone's taste, the church furnishings are certainly in harmony with each other. It was reported of the church's opening: 'We have it on the authority of one of Mr Scott's assistants, that although prevented from personally superintending the construction, and compelled by a sudden call to the Continent to forego the pleasure of being present at its consecration, the architect devoted to the plans an unusual amount of care and attention, being resolved that the building should be a gem among the many which have made his name famous.'

Even those not enamoured of Victorian stained glass may find the windows in St Stephen's a delight; I certainly did. These were made by Clayton & Bell and enhance greatly the otherwise stark interior.

24. HUNTINGFIELD, ST MARY THE VIRGIN

Huntingfield looks much like many other Suffolk churches from the outside. The sight that awaits the visitor inside, though, simply takes your breath away. Both the nave and chancel roofs are ablaze with medieval colour. There are angels, banners, crowns and shields, as well as other religious iconography and texts. This is not the work, however, of a cast of hundreds in the Middle Ages. Instead, the whole ceiling was painted by one woman between 1859 and 1866. Mildred Holland was the rector's wife who, although a keen artist, was a novice to church painting. She was inspired by her husband William's devotion to the neo-medieval practices of the Oxford Movement and the project was a true labour of love. Apart from help from workmen to erect the necessary high scaffolding and advice from an expert on medieval decoration, Mrs Holland worked alone, often spending long periods of time on her back wielding a paintbrush. The years of hard work on this masterpiece sadly took its toll on Mildred and she died at a relatively early age. Such was Revd Holland's grief that he commissioned a tall, elaborate canopy for the medieval octagonal font as a memorial to his wife.

Mildred Holland's roof is so spectacular that it is easy to forget to take time to appreciate all the other interesting fixtures, fittings and fabric of St Mary's. As far as the structure is concerned, much of this has been renewed and updated

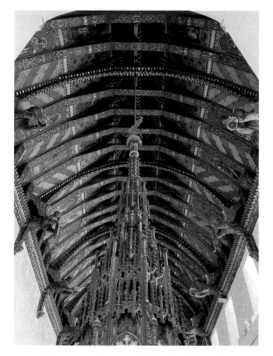 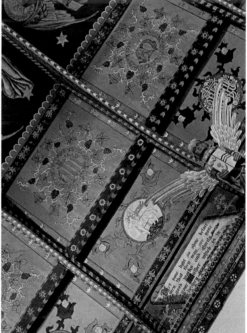

Above left: Huntingfield. The Victorian font canopy reaching up towards Mildred Holland's glorious painted nave ceiling. (Photo by Sarah Doig)

Above right: Huntingfield. The chancel ceiling features biblical texts alongside the angels. (Photo by Sarah Doig)

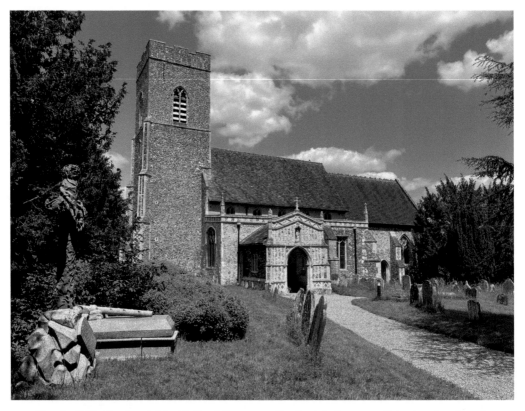

Huntingfield. Revd and Mrs Holland lie at rest (in the left foreground) in the churchyard. (Photo by Sarah Doig)

over the centuries but the north wall of the nave is Norman. Another thirteenth-century stonework survives. The Vanneck family chapel, north of the chancel, now houses the organ. On the parapet of the exterior of this nineteenth-century red-brick extension sits two wonderful stone greyhounds. My final 'must-see' at Huntingfield is the table tomb in the chancel to John Paston (d. 1575) and the inscription which, although not the original painted script, gives a contemporary account of his life and loves.

25. Icklingham, All Saints

Sometimes it pays off to be the poor relation. Of the two churches in the small village of Icklingham, the more central of them, St James, became the main place of worship and was therefore Victorianised. All Saints, however, on the edge of the village was left largely untouched and, in 1973, responsibility for its upkeep was transferred to the Redundant Churches Trust (now the Churches Conservation Trust). Happily, for church historians, All Saints therefore possesses a whole host of original features stretching back many centuries.

All Saints is an extremely photogenic church, especially from the outside. Apart from the tower, all the roofs are thatched. It sits on an elevated position above the main road from Bury St Edmunds to Mildenhall. There was a Roman settlement

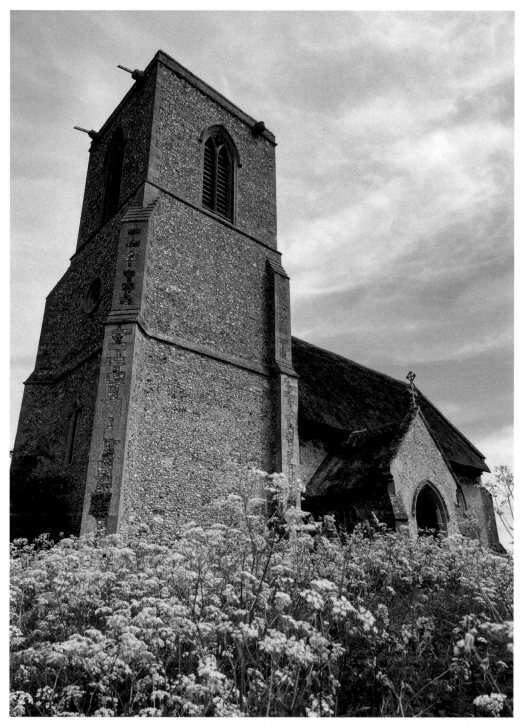

Icklingham, All Saints. The ugly duckling of the village turned into the beautiful swan. (Photo by Sarah Doig)

in Icklingham and All Saints was situated on an important junction of the Icknield Way. An ancient track known as the 'Pilgrim's path' lies just to the north of the church. The small Norman church consisted of the present-day nave and possibly part of the chancel. The large tower was completed in around 1300 when the south aisle was also added.

The surviving windows display a range of different styles of architecture and show the development of more intricate tracery. The largest window, at the east end of the aisle, comprises five lights above which is beautifully delicate, reticulated tracery. Most of the windows now contain clear glass but some fourteenth-century original stained glass survived the onslaught on 'superstitious pictures and inscriptions' by the Puritans and is well worth a closer look: the detail is superb, especially the two saints depicted in the window to the east of the porch.

Inside we find mainly fifteenth-century backless benches and the lower part of the original rood screen dating from the same period. The pulpit and reading desk (now towards the back of the aisle) are seventeenth century, as are several furnishings in the chancel and sanctuary including the communion rails and reredos. The floor tiles in this area are one of All Saints' real treasures. They date from the early 1300s and comprise various designs, including cinquefoils, birds and faces (both human and those of lions), all worn by the feet of ages.

26. IKEN, ST BOTOLPH

The parishioners of Iken have a phoenix in their midst. The church of St Botolph has renewed itself several times over the centuries, at least once literally rising from the ashes of its predecessor. Archaeologists and historians have proved that this idyllic village, overlooking the Alde estuary, was where St Botolph founded a monastery in AD 654. Two centuries later, this 'minster', as it is described in the *Anglo-Saxon Chronicle*, was destroyed by the invading Danes and it was probably shortly after this that a wooden church was built. The present-day church, which can be dated to the early Norman period, sits on the clay foundations of that earlier Saxon church. Many visitors come to St Botolph's to see the remarkable Saxon treasure now on display at the back of the nave. It is a carved stone cross shaft which was found in the base of the tower. It is thought that this formed part of a cross erected on this site to mark it as a holy place after the destruction of St Botolph's monastery.

In the Middle Ages, the nave was reroofed, and the windows were replaced by larger ones. The tower was built in the 1400s and furnished with four bells which are still rung today. They were joined by a new treble bell in 2000 to mark the millennium. There was also once a rood screen which has long since disappeared (although the rood loft staircase remains), along with other paintings, carvings and stained glass in line with the liturgical needs of the Reformed Church in the mid-1500s. It was during the 1850s that the then half-ruined chancel was renewed in the early fourteenth-century decorated style of architecture, and it is that incarnation that we see today. The English oak altar reredos, based on Leonardo da Vinci's painting of *The Last Supper*, and panelling were installed at this time. The panels either side have small carvings of farm animals and wildfowl.

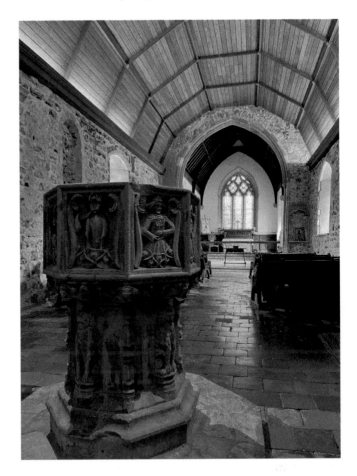

Iken. Four angels
around the bowl of the
font hold Instruments
of the Passion: heart,
lance, nails and whip.
(Photo by Sarah Doig)

It was in April 1968 that tragedy struck when sparks from a bonfire in the churchyard set the thatched nave roof alight and reduced that whole part of the church to a ruin. It took until the early 1990s to completely renew the nave.

27. IPSWICH, ST MARY AT THE ELMS

Choosing just one of the numerous Anglican churches in Suffolk's county town to feature here is an extremely hard task, and I am sure many will disagree with my choice, which is not supposed to be the grandest or the one packed with the most features. Instead, it reflects a few key moments in the history of Ipswich and, many more will agree, the exterior certainly oozes charm. St Mary at the Elms – named for the elm trees which used to stand nearby – was first built in the fourteenth century either on or near the site of an earlier church dedicated to St Saviour. It is possible that the Norman doorway came from St Saviour's and perhaps even the door itself. The handsome red-brick tower and the north aisle were added in the Tudor period, and these are said to be constructed of bricks brought from The Netherlands by Cardinal Thomas Wolsey which were originally destined to be used by the college he had started to build in the town but was never completed

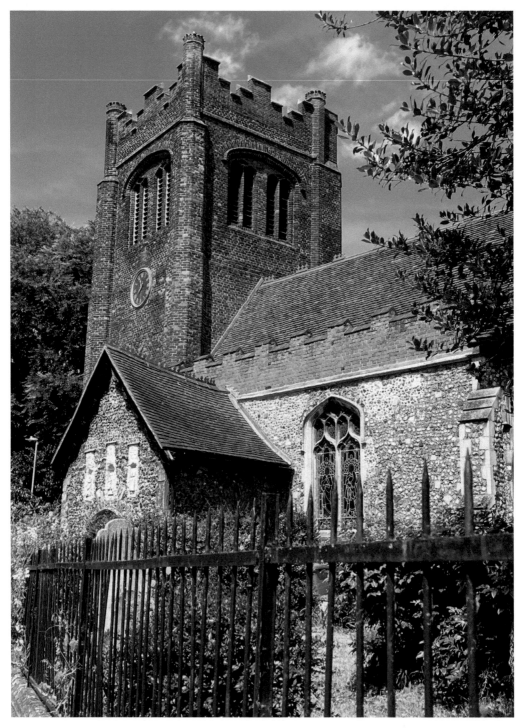

Ipswich, St Mary at the Elms. Echoes of royal palaces at the top of the early Tudor tower? (Photo by Sarah Doig)

Above left: Ipswich, St Mary at the Elms. The shrine, with an oak replica of Our Lady of Grace, was re-established in 2002. (Photo by Sarah Doig)

Above right: Ipswich, St Mary at the Elms. It is said that this is the third oldest door in the country. (Photo by Sarah Doig)

due to the cardinal's downfall at the hands of Henry VIII. The font is possibly the original fifteenth-century one, but was recut in the Victorian era when extensive alterations took place, including the construction of an extension to form the new chancel.

Like other places of worship in this much-modernised town, St Mary at the Elms now sits in a rather humdrum street, tucked in behind office blocks and retail outlets. One of the church's most recent arrivals has its origins in an even more unprepossessing thoroughfare nearby called Lady Lane. Here, a chapel once stood which held a shrine to Our Lady of Grace where miracles were said to have taken place. It was a shrine to which monarchs came. In 1517, Catherine of Aragon, Henry VIII's first wife, visited the shrine and then in 1522, The king himself prayed at the shrine in the hope of a miracle of a baby boy and heir to the throne. Because of this royal patronage, pilgrims from across the country, and probably further afield, flocked to pay homage at the shine of Our Lady. When Henry VIII broke from Rome and suppressed Catholic institutions, the shrine was closed. It is said that the original carved wooden statue of Our Lady from the shrine was taken to London to be burnt but was, instead, rescued by Catholic sailors and smuggled to Nettuno in Italy.

28. Ipswich, Unitarian Meeting House

When the novelist and nonconformist Daniel Defoe visited Ipswich in the 1720s, he commented: 'There is one meeting house for the Presbyterians, one for Independents and one for the Quakers. The first is as large and as fine a building of that kind as most on this side of England, and the inside the best finished of any I have seen.' The fine Presbyterian meeting house Defoe describes is now known as

Ipswich, Unitarian Meeting House. Eighteenth-century architecture stands alongside an office block dating from the 1970s. (Photo by Sarah Doig)

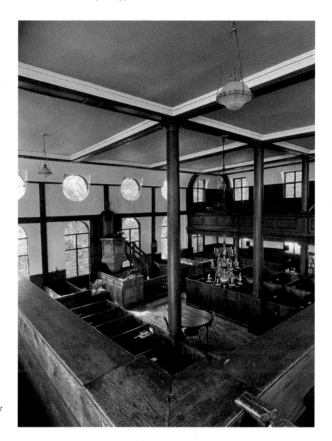

Ipswich, Unitarian Meeting House. Despite the dark wood furnishings, the large windows make the interior surprisingly bright. (Photo by Sarah Doig)

the Unitarian Meeting House and stands in a courtyard off St Nicholas Street. It was built in 1699–1700 by Joseph Clark of Ipswich for just over £256 (excluding windows, galleries and internal fittings) and is still in use today. It is timber-framed and is believed to be the only remaining example of a purpose-built dissenting meeting house of this kind.

Today, the carefully oft-restored interior is much as it would have been when the meeting house was built, including box pews made of pine. In a few pews, there are wooden pegs which are believed to be wig-pegs on which gentlemen could place their hairpieces whilst worshipping; these were still fashionable when the meeting house was opened. There also remain some locks on the pews which date from a time when families rented their own pews and therefore had a key with which to unlock 'their' row. The Dutch brass chandelier, the clock over the organ, and most of the leaded glass are also original features.

The design is typical of those built by dissenting congregations at this time. There would have been a communion table in the central space but the feature which now dominates is the pulpit in the centre of the south wall. The acoustics in the building are such that a sounding board above the preacher's head is unnecessary. This splendid hexagonal pulpit is believed to be from the workshop of the Anglo-Dutch master woodcarver Grinling Gibbons, and so, if not by Gibbons himself, one of his pupils is responsible.

29. KEDINGTON, ST PETER & ST PAUL

St Peter & St Paul, Kedington exudes a very lived-in feel. It could not be described as a pretty church but what it lacks in looks it makes up with the amazing array of almost everything you might expect to find in a building whose history stretches back to the earliest days of Christianity.

Sitting on the east window ledge, behind the altar in the chancel is a beautiful ninth-century Saxon cross which may have once formed the head of an outdoor preaching cross. It was found under the floor not far from where it now rests during Victorian restorations. This cross dates from a time well before the Barnardiston family worshipped in this parish church. The Barnardistons were lords of the manor from the thirteenth century until 1745 and there are over twenty monuments to twenty-seven generations of them in the church. These include one to Sir Thomas (d. 1619), his wife, Elizabeth (d. 1584), and their five sons and three daughters, and a large wall monument and chest tomb of Sir Thomas Barnardiston who died in 1610. Above his effigy, his two wives kneel in prayer. His daughter Grissel who died at the age of just sixteen, has her own grand memorial. There is a poignant inscription on this monument which informs us that she was: 'Too dear to Frendes, too much of men desir'd. Therefore bereaft us with untimely death.'

Kedington has a wealth of different types of pews, demonstrating how the church has been altered to adapt to its congregation's needs. There are some basic

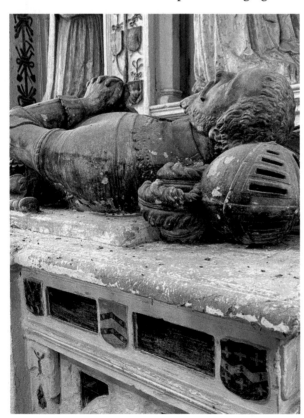

Kedington. Sir Thomas Barnardiston's helmet and gauntlets hang above his tomb. (Photo by Sarah Doig)

Above: Kedington. A useful wig stand sits below the pulpit. (Photo by Sarah Doig)

Right: Kedington. The stone cross behind the high altar dates from the ninth century. (Photo by Sarah Doig)

medieval benches and then more elaborate ones with a linenfold pattern on the ends. In the aisles are box pews dating from the seventeenth to nineteenth century, and children were accommodated in the eighteenth century in special pews at the back corners of the nave. At the grander end of the scale is the magnificent hall pew of the Barnardiston family which incorporated parts of an earlier painted parclose screen.

The triple-decker pulpit with a sounding board is considered one of the country's finest and was used by the Puritan Samuel Fairclough, who was Rector of Kedington for nearly thirty-five years and who presided over the witch trials in Bury St Edmunds instigated by Matthew Hopkins.

30. KETTLEBASTON, ST MARY

If ever there was an example of a parish church constantly beloved of its worshippers over time it is St Mary's in the tiny village of Kettlebaston. The community lies hidden, deep in the south Suffolk countryside, overlooked by many tourists who flock to the great wool churches of Lavenham and Long Melford. Kettlebaston church is a homage to sensitive and thoughtful rebuilding and restoration, and is therefore an absolute delight to explore.

The first feature to greet the visitor is the outdoor shrine on the south-east buttress of the chancel. The niche is a rare survival from the fourteenth century

Kettlebaston. The modern rood screen and reredos. (Photo by Sarah Doig)

Kettlebaston. The decorated Norman window niche in the north wall of the nave. (Photo by Sarah Doig)

and now houses a twentieth-century coloured replica of the Kettlebaston *Coronation of Our Lady*, one of the fragments of beautiful medieval alabaster carvings uncovered during Victorian repairs in the church. It is thought that these carvings, now in the British Museum, may have formed part of an altarpiece destroyed during the Reformation.

The church interior is light and uncluttered. The original Norman nave is still represented by the square bowl font and by the window in the north wall – another twentieth-century discovery. The painted red-ochre decoration dates from the mid-thirteenth century. A century later, in 1343, the church was greatly expanded with a tower and new chancel. The nave was given a new roof: look up and you can see the carefully restored tie-beam and crown post timber structure resting on stone corbels with fun little animal faces. Two nave altars stand on either side of the east end just as they would have done during the medieval period. A surviving stone piscina in the lowered northern windowsill would have served the original altar on this side. One of the outstanding chancel features added at this time was a finely carved, three-seat sedilia and piscina upon which no expense seems to have been spared.

For me, the *pièces de résistance* are two early twentieth-century additions, although strictly speaking they were intended as replacements for a rood screen and high altar reredos, long since destroyed by sixteenth-century reformers. The colour was mostly added in the 1940s and 1950s.

31. LAKENHEATH, ST MARY THE VIRGIN

Fighter jets from the nearby RAF airbase thunder overhead, seemingly rending the sky in two, and yet once inside St Mary's, I easily find myself transported back in time. Despite the many historical gems in this large church, it is not a building stuck in the past: the trappings of twenty-first-century worship, such as the children's play area and the contactless card reader for donations, give it a lived-in atmosphere.

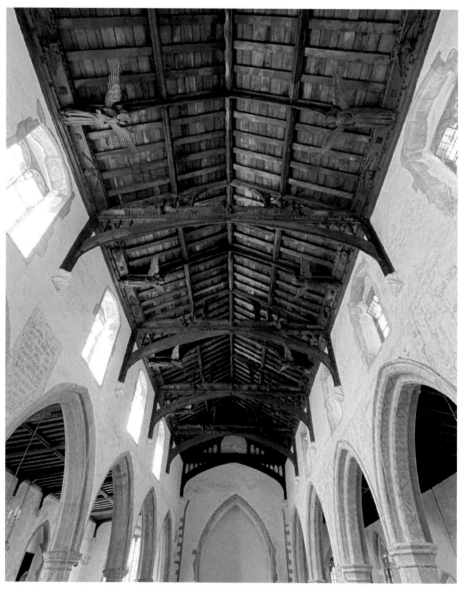

Lakenheath. Early fifteenth-century angels, rather than modern planes, fly over St Mary's congregation. (Photo by Sarah Doig)

Lakenheath. The ghost of a once
brightly painted figure, possibly a
medieval patron. (Photo by Sarah Doig)

The jewel in Lakenheath's crown is, undoubtedly, the set of wall paintings which give us a real sense of how the church would once have been a riot of colour. They were, of course, not just painted as mere decoration. Instead, they provided the largely illiterate medieval congregation with a means to learn about the great Biblical events and stories from the Gospels. The remains of no fewer than five schemes of wall painting dating from around 1220 through to the early seventeenth century wait to be explored. Only a small fraction of the original paintings is visible today, but they include angels from the earliest phase of decoration, a fourteenth-century depiction of the Virgin and Child, and scenes from the Passion of Christ. The last phase substituted the word of God over images.

Other notable and equally important medieval survivals include the octagonal, highly decorated font which was either installed when the Norman nave was extended westward or was moved to Lakenheath from the old church of St Peter in Eriswell after the Reformation, and some of the benches. These have poppyheads with all manner of man and beasts on, including a tiger, a beaver, a unicorn and a whale swallowing a fish. In 1483, a wealthy benefactor left money for the 'stooling' of the church and so it is likely that these intricate pews formed part of this project.

An unusual feature of St Mary's, evident only from the outside, is the two-storey brick and flint extension built onto the west face of the thirteenth-century tower. This was probably constructed in the 1600s and has, over the centuries, been variously used as an office for the manor and a schoolroom.

32. LITTLE SAXHAM, ST NICHOLAS

The church tower at Little Saxham has a real wow factor and I am sure nobody would disagree with Nikolaus Pevsner who called it 'the most spectacular Norman round tower in Suffolk'. The lower part is thought to be Saxon and is of fine workmanship, but it is the superb Norman arcading around the belfry that is the icing on the cake. The elegant south door of the church, now sheltered by a medieval porch, is also early Norman.

Little Saxham church entertained royalty in the second half of the seventeenth century and it is little wonder, then, that the finely crafted pulpit dates from this time when it was vital to impress the monarch. Charles II stayed at the home of William, 1st Baron Crofts, in nearby Saxham Hall on at least four occasions and by all accounts, the Croft family hospitality was enjoyed by the king. So much so, that the famous diarist Samuel Pepys, who accompanied the royal party to Saxham Hall in April 1670, recorded that Charles attended church the day after having been entertained lavishly. Whether it was the tedium of the lengthy sermon or the effects of the excess alcohol from the previous night (or perhaps both!), it is rumoured that the king nodded off, subsequently having to ask for it to be printed.

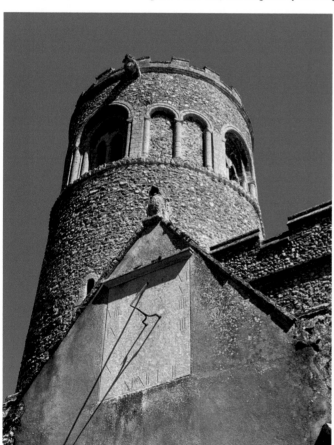

Left: Little Saxham. Round towers were cheaper to build in Suffolk as they used locally sourced flint rather than the more costly stone needed to construct corners. (Photo by Sarah Doig)

Below: Little Saxham. A medieval poppyhead bench end. (Photo by Sarah Doig)

Another version of the same story suggests that a rather more sober version of Charles was so impressed by the preacher's theme, that he had the text published so others could benefit from the words of wisdom.

The vestry – which is understandably locked but can be opened by prior arrangement – was built in 1520 as a chantry chapel by Sir Thomas Lucas but was taken over by the Crofts family as their memorial chapel. It houses a large black and white marble monument to William Crofts (d. 1677) and his second wife, Elizabeth. Both are represented by life-size effigies of the couple, Lord Crofts in his full peer's robes.

A rather more mundane, rare survival from the seventeenth century is the bier, with sliding extendable handles, which was used to transport a coffin or shrouded corpse to and from the church before burial.

33. LONG MELFORD, HOLY TRINITY

It is very easy to run out of superlatives when describing this magnificent Suffolk church. Larger than some cathedrals in the country, with a nave the longest of any parish church in England, and with a separate triple-gabled Lady Chapel surpassing the capacity of many of the county's churches, it is equally easy to forget that this is a village church. Holy Trinity is, though, a village church with a difference, namely a visual statement of the prosperity of the medieval wool

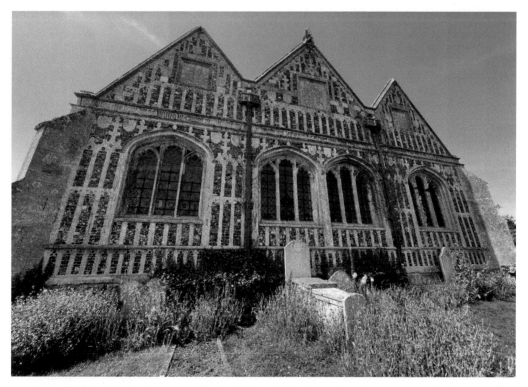

Long Melford. The flushwork on the Lady Chapel includes an inscription praying for the souls of the patrons and their families. (Photo by Sarah Doig)

Above left: Long Melford. A rare medieval lily crucifix in stained glass in the Clopton Chantry Chapel. (Photo by Sarah Doig)

Above right: Long Melford. The Caen stone reredos dating from 1877. (Photo by Sarah Doig)

trade. The founder, John Clopton, who is buried in his own chantry chapel in the north-east corner, was a wealthy clothier who financed the near-complete rebuild in the fifteenth century. Since then, many lords of the manor and other prominent landowners have provided funds for the church's upkeep and subsequently have had elaborate tombs and monuments erected in their memory.

The exterior is a stunning showcase of flint flushwork and Perpendicular Gothic windows. The tower, though, is not as old as it seems. In 1701, a lightning strike damaged the original tower, and it was subsequently demolished. The new tower which replaced it was in Georgian red brick and plaster but by the late nineteenth century, some of the rendering had broken away and its rather ugly appearance was considered inappropriate for such a grand church. So, a fundraising campaign was launched as part of Queen Victoria's diamond jubilee celebrations. The resulting replacement matches the style of the body of the church and was dedicated in 1903. The new pinnacles were named Victoria, Edward, Alexandra and Martyn after the then late queen, the new king and his wife, and in honour the Revd C. J. Martyn, a minister who oversaw renovations at Holy Trinity.

Long Melford's medieval stained glass, mostly in the north aisle, is regarded as some of the finest in the country. The people depicted here are mainly family and friends of John Clopton, although there are, of course, some religious images, most notably the *Pietà* image of the crucified Christ in the Virgin Mary's arms

which is one of only four surviving such examples in this country. If you look carefully, you will notice that the small roundel of three hares over the north door has only three ears, each of the ears being shared by two hares.

Finally, another treasure not to be missed is the alabaster panel depicting the Adoration of the Magi. It was found under the chancel floor in the eighteenth century and is thought to date from around 1350, over a century earlier than the present church building.

34. LOWESTOFT, OUR LADY STAR OF THE SEA

On 7 June 1902, the *Lowestoft Journal* featured a lengthy and detailed report which began: 'One of the principal features of Lowestoft's progress in the past decade has been the building of places of worship; but it is safe to say that the most beautiful and striking of them all, both in its architectural and its internal appointments, is the handsome Roman Catholic Church of Our Lady Star of the

Lowestoft, Our Lady Star of the Sea. Kittiwakes roosting on every available ledge. (Photo by Sarah Doig)

Sea, in Gordon Road, which was opened on Thursday with stately and impressive ceremonial.' This splendid example of turn of the century Gothic Revival style, the most easterly Roman Catholic church in England, now overlooks the sadly run-down bus station and shopping centre.

On entering the church, your eyes are drawn to the sanctuary with its stunning reredos, ceiling and five stained-glass windows. The church suffered bomb damage during the Second World War and the glass was restored in 1952. The ceiling, too, which had only just been completed, suffered from the blast but was renovated. The Arts and Crafts influence is evident in the Stations of the Cross and in the windows in the main body of the church.

It is now recommended that members of the congregation take umbrellas with them at certain times of year but not, as you might expect, when it is raining. Instead, it is a sensible precaution to avoid bird droppings landing on your Sunday best. The tower is home to a colony of over 200 kittiwakes. These seabirds are a protected species and so the church community has learned to live with their very special visitors. It takes an army of volunteers to clear the steps and entrance on a regular basis, and to ward off the smell of the guano, they make sure they burn plenty of incense!

35. MILDEN, ST PETER

This is a parish that has clearly cherished its churchwardens who, I am sure, in return took great care over their delightful little church and the welfare of its congregation. One of the simple seventeenth-century oak pews at the back of

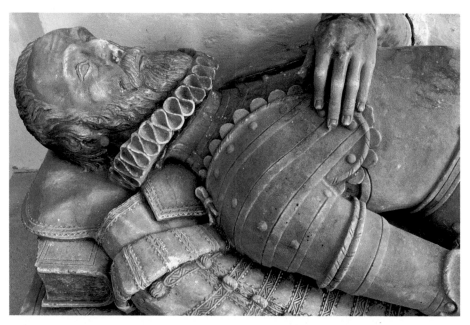

Milden. James Alington reclines in full armour with his head resting on a prayer book and a Bible. (Photo by Sarah Doig)

St Peter's is inscribed with the name of one of these former parish officers, and there is an equally delightful wall plaque commemorating three successive generations of the Hawkins family who, between 1814 and 1926, served as churchwardens.

The Norman church of St Peter's stands on a peaceful high point in the south Suffolk landscape, above the valley in which the much grander church of Lavenham sits. Although the south porch is later, the doorway it shelters is Norman, as is one surviving window in the south wall of the nave. It has no chancel arch; the only feature defining the boundary between the nave and chancel is a small step. The chancel is dominated by a once fine alabaster memorial to James Alington (d. 1627) of Milden Hall. It was formerly a much larger monument which extended high up the wall. The feet of the effigy is missing, and other features have long since disappeared, such as the cherubs and columns.

The plain whitewash of the walls and the clear glass in the windows give the interior a very airy, timeless feel. The church lost its medieval square tower in the mid-nineteenth century after storm damage made it unsafe, and this was never rebuilt. Instead, a small bellcote was erected.

Milden's rediscovered wall paintings, too, are understated. These delicate foliage patterns have been dated to the early or mid-thirteenth century, making them among the earliest in Suffolk.

Milden. An inscription on the back of the pew tells us that the churchwarden was William Stud, junior. (Photo by Sarah Doig)

36. MILDENHALL, ST MARY

You must look heavenward to appreciate the real splendour of St Mary's: to the magnificent 50-plus-metre tower, to its breath-taking angel roof; and to the elegant, stone vaulted ceiling and bosses of the north porch. Mildenhall is the largest parish in Suffolk and today the town is, sadly, down at heel. Its church, however, tells a very different story of a wealthy town of the Middle Ages, thanks to the fish from the nearby fens and the rabbits from the Breckland area.

It is Sir Henry Barton (d. 1435) whom the people of Mildenhall must thank for some of the riches inside its place of worship. He gave money for the font and

Mildenhall. The upper floor of the north porch was a Lady Chapel. (Photo by Sarah Doig)

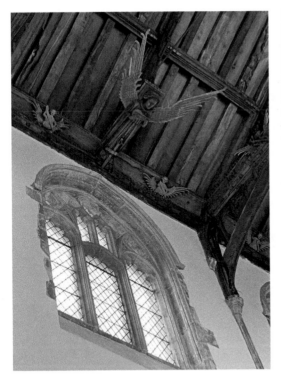

Above left: Mildenhall. An angel musician high above parishioners' heads. (Photo by Sarah Doig)

Above right: Mildenhall. An angel at prayer bequeathed by Mabel Cautley and designed by her husband. (Photo by Sarah Doig)

probably also financed the nave roof. Barton was a local man who rose to become Lord Mayor of London and although he was buried in the old St Paul's Cathedral, has a cenotaph tomb in the west end of the south aisle here in St Mary's. It is even possible that his pockets were deep enough to pay for the construction of the two-storey north porch which was built at the same time.

The oldest part of the church we see today is the chancel, which is thirteenth century. This was extended in the early 1300s when the impressive east window with its stone tracery was installed. The current stained glass is Victorian and shows St Peter and eleven apostles, the last supper, the events leading up to the crucifixion and the Ascension of Christ. At the opposite end of St Mary's is a rather more modest window of which two of its lights are dedicated to women who served the church community. One is to Mary Anne Jolly who died in 1908 and who had cleaned the church for eighteen years. The other is in memory of Mary Louisa Fordham (d. 1949) who had rung the bells here for twenty-two years.

It is perhaps not surprising to discover that the richly carved benches in the nave were designed by the Diocesan architect and church historian Henry Munro Cautley. Although he was not a Mildenhall resident, the affection he felt for St Mary's is clear from his extensive and effusive description of the church in his *Suffolk Churches and Their Treasures*.

37. NORTH COVE, ST BOTOLPH

We owe a debt of gratitude to Victorian restorers for uncovering St Botolph's great treasure. That said, the full glory of these series of wall paintings was only able to shine through the following work in the 1980s during which much of the nineteenth-century overpainting was removed. Although the cleaned paintings covering the entire length of both north and south chancel walls are very faint, these masterpieces tell us so much of how the Bible stories were told to fourteenth-century churchgoers. One of the scenes, popular in the Middle Ages, is that of the Doom or Last Judgement, with Christ seated on a rainbow, flanked by the Virgin Mary and St John the Baptist. Two angels are holding symbols of the Passion, and four trumpeting angels are heralding the arrival of the souls of the recently departed, arising from their graves and coffins. On the facing wall are scenes of the events before and after the Crucifixion. A painted vine pattern is also prominent on the walls which is believed to be the symbol of St Botolph to whom the church is dedicated.

For me, two other real treats in store for the visitor to North Cove are the font, which dates from the early 1400s and has beautiful carvings that are in

North Cove. Christ is taken down from the cross. A detail from the wall painting on the north wall of the chancel. (Photo by Sarah Doig)

very good condition, and various delicate stained-glass windows. Of course, the church exterior is also special. The long, thatched roof of the nave and chancel sits perfectly atop the flint walls which have been, in places, reinforced and replaced by red brick. The tall, thin tower and the attractive porch are greatly enhanced aesthetically by this later brick, and two pretty, pink rose bushes sit on either side of the porch entrance, lending a rather fairy-tale air to the view.

38. ORFORD, ST BARTHOLOMEW

'Orford was once a good town, but is decay'd, and as it stands on the land-side of the river, the sea daily throws up more land to it, and falls off itself from it, as if it was resolved to disown the place, and that it should be a sea port no longer.' This description written by Daniel Defoe following his visit in the 1720s bears no relation to the Orford of today to which visitors flock to sample the local seafood and to ogle at the picture-perfect cottages. However, what the author does allude to is Orford's earlier importance: it had a flourishing port and market in the twelfth century when its two largest buildings – the castle and church – were built. While present-day tourists see a castle which has changed little since it was first constructed, those who venture to St Bartholomew's see a very different structure. That said, the ruins of the original chancel remain and give us an idea of the

Orford. Ruins of the Norman chancel. (Photo by Sarah Doig)

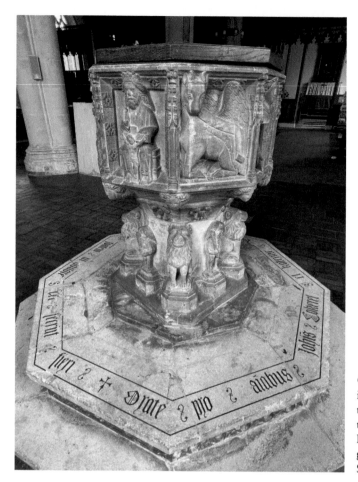

Orford. The inscription around the base of the font tells us that John and Katherine Cockerell gave it. (Photo by Sarah Doig)

grand scale of the Norman church. Its present-day successor is, perhaps, equally imposing, especially its chunky tower.

Inside, as well as outside the church, new rubs shoulders with old. A new carved oak and glass screen has been installed in the tower arch through which you can catch sight of the medieval tower stairs, and the late twentieth-century *Statue of Noah and the Dove* by Lilane Yauner, marking the fiftieth Aldeburgh Festival and celebrating Orford's close association with Benjamin Britten, stands not too distant from the beautiful early fifteenth-century font with its lions and wild men around the stem. The spectacular 1924 pipes of the modern nave organ encased in American red oak contrast with the modest late nineteenth-century organ in the choir, and over the entrance of the medieval south porch stands a twenty-first-century statue of St Bartholomew cradling the church in his right arm.

Orford's church has benefitted from much refurbishment over the centuries. Around the time of Defoe's visit, a new communion table, Commandment boards, pulpit and royal arms were installed and in the late nineteenth century, the nave and north aisle were both reroofed. The twentieth century saw the arrival of new lecterns, the screen and choirstalls.

39. PRESTON, ST MARY THE VIRGIN

Buried deep in the south Suffolk countryside is perhaps one of the most understated churches in the county. There is a hint of what might be inside the church when you walk around the exterior and, understandably, pause to marvel at the glory of the north porch. Unlike the rest of the elegant building, this fifteenth-century porch is covered in fine flushwork and over the door are emblems of the Passion and of the Trinity. Inside the door, there is an altar tomb with a marble top thought to be that of either that of a medieval founder of the church or else the builder of the porch himself. This spectacular porch, together with the nave and aisles, was built at around the same time as its more famous neighbour at Lavenham. The twice rebuilt tower and the chancel have fourteenth-century origins although there was an earlier church on the site, and the square twelfth-century font almost certainly comes from this previous incarnation.

St Mary's has a surprisingly bright interior, helped by the large, low clerestory windows. This glass and other windows in the aisles are peppered with fifty-two heraldic shields of Suffolk families, not by all means connected with this area of the county. There were once far more of these shields set into the windows, arranged by Robert Reyce (d. 1638) of Preston Hall who was a patron of the church, as well as a historian and lover of heraldry. He and his wife are buried either side of the altar in the chancel.

You may or may not be lucky to see Preston St Mary's foremost treasures on your visit since they are sometimes loaned out for national exhibition. These are

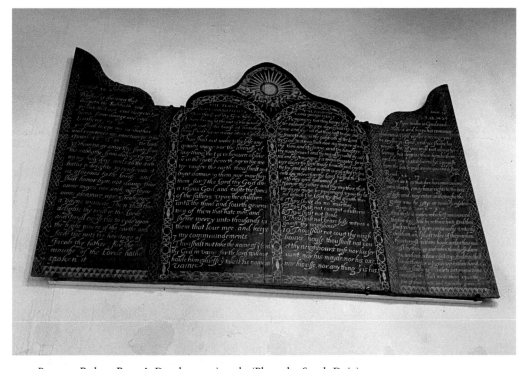

Preston. Robert Reyce's Decalogue triptych. (Photo by Sarah Doig)

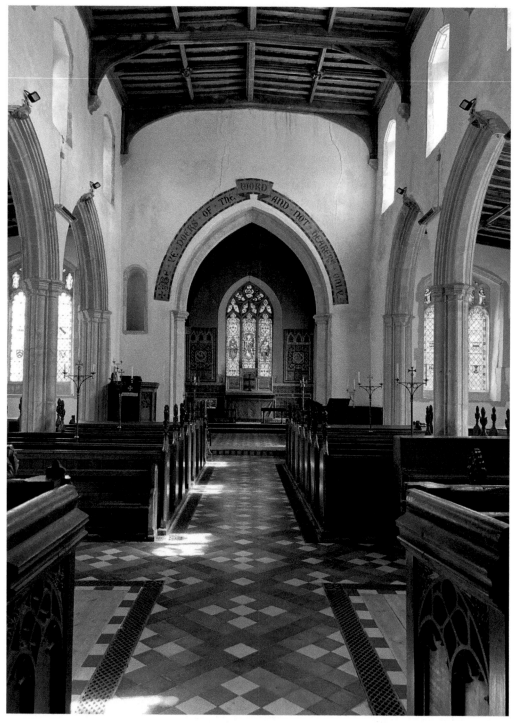

Preston. Looking down the nave through the doors of the restored chancel screen, the lower half of which is in the tower arch. (Photo by Sarah Doig)

a matching pair of oak, triptych boards of the Ten Commandments or Decalogue and the royal coat of arms of Elizabeth I. These were commissioned by Robert Ryece. The arms appear to have been cut down from a rectangular shape to match the Commandment board and those we see today have been painted over the arms of Edward VI, Elizabeth's half-brother. Sadly, a third inscribed board has long since vanished from the church but which Ryece recorded in his *Breviary of Suffolk*, and which celebrated the defeat of the Spanish Armada in 1588.

40. RAMSHOLT, ALL SAINTS

The rather unusual buttressed tower of All Saints, Ramsholt caused Arthur Mee to describe it as 'queer' in his *King's England – Suffolk*, and it is certainly an almost unique sight. The only other example of such a round tower is at Beyton which is, perhaps, not as elegant as this one. Locals say that Ramsholt's tower was built by the Saxons to keep watch for the invading Vikings and its position, on an elevated piece of ground overlooking the village and the River Deben, is certainly one of the most dramatic in the county.

Much of the Norman church remains, although the clear glass windows are mainly medieval. Stepping into the church, through the brick and flint south porch and the Norman doorway, is a real delight and it is hard to believe that this church was once unloved and derelict. The simple brick floor, timber ceiling, plain, wooden box pews and two-decker pulpit are in pristine condition and look as if they have always been there. Far from it: in the mid-nineteenth century the

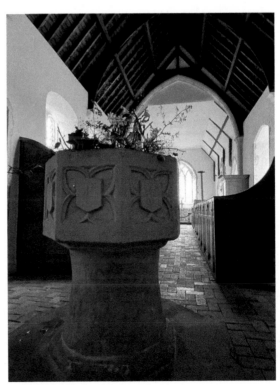

Ramsholt. The plain interior is flooded with light from the clear glass windows. (Photo by Sarah Doig)

nave was without a roof and the walls were 'as green as the grass with which they are surrounded' as one visiting archdeacon reported. Then the church was restored, rather eccentrically adding seating for the congregation that would have been more in vogue a century or so earlier. These pews range from straight ones to those arranged for families in a square, and all face towards the pulpit rather than to the altar, thus reinforcing the fact that it was the Bible teaching, rather than Holy Communion, that was the focus of Anglican worship at this time.

41. RATTLESDEN, ST NICHOLAS

This is an extremely attractive church in a lovely, typical mid-Suffolk village. Both inside and outside of St Nicholas, there is something for everyone, representing the constant need to restore and renew as and when repairs were needed and when fashions and beliefs altered.

There was a church here at the time of Domesday which was rebuilt in the early English style of architecture in the 1200s. The fourteenth century is represented by the tower and aisles and the finely crafted font. Then the church seems to have been remodelled into a building more like we see today in the 1600s when large new Perpendicular windows were added, and the pulpit and nave altar installed. The height of the nave roof was also raised and a magnificent double-hammerbeam ceiling was constructed, although the sixty-six angels we see today

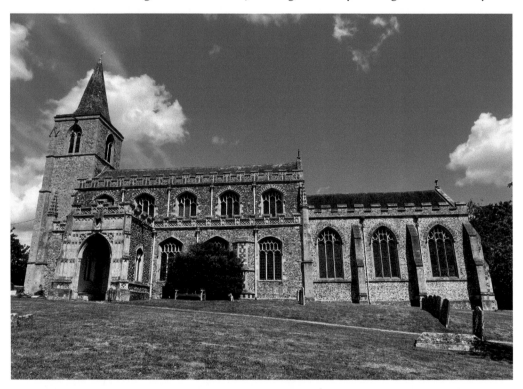

Rattlesden. St Nicholas stands on high ground in the middle of this attractive village. (Photo by Sarah Doig)

are nineteenth-century replacements of those damaged by the Puritans. Rattlesden was the subject of major late Victorian and Edwardian restorations of the exterior and of the interior, when most of the woodwork was renewed, including the rood screen and three-seater sedilia in the chancel.

There have been chapels in both south and north aisles for many centuries but the current incarnations date from the twentieth century. The Lady Chapel to the south now has a parclose screen erected in 1916 and a wrought-iron gate, both given in memory of local residents. The north chapel is now the American Chapel, dedicated to the US Forces that were based in the nearby aerodrome during the Second World War.

Many of the stained-glass windows were also given as memorials in the nineteenth and twentieth centuries, although there are two windows which contain a wonderful assortment of medieval glass. The one in the north aisle was assembled in 1901 in memory of a former seventeenth-century rector of Rattlesden by one of his descendants. One of my favourite windows is at the west end of the south aisle and is the Children's Window created and installed in 1921. It shows Jesus surrounded by children of different races. Six children featured in the Bible appear in the upper lights and at the bottom are pictures of St Nicholas' font, altar and reredos.

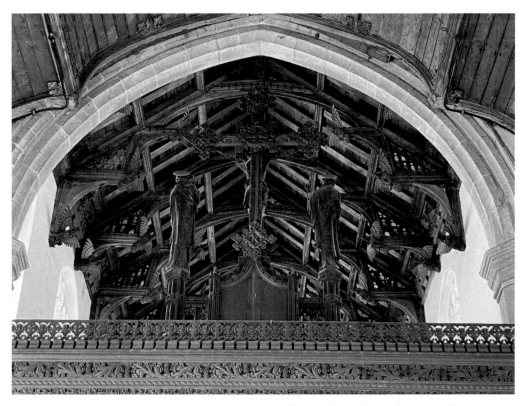

Rattlesden. The double-hammerbeam roof viewed from behind the rood screen. (Photo by Sarah Doig)

42. REDGRAVE, ST MARY

Like many other Suffolk churches, the history of St Mary's is inextricably linked to the local squires, although perhaps none more so than at Redgrave. Its proportions are cathedral-like and evidently no expense was spared in its original fourteenth-century construction, as well as the subsequent additions and alterations. That said, this is not immediately apparent from the exterior. There is no extensive flushwork, instead just some monograms between the late fifteenth-century clerestory windows. The replacement red-brick tower was refaced in the late eighteenth century in local white Woolpit brick to match Redgrave Hall, giving the church a rather utilitarian look.

Inside, though, at every turn we are reminded of the splendour and wealth of the great families who have lived in nearby Redgrave Hall – the Bacons, the Holts and the Wilsons – in the form of thirteen funerary hatchments, the monuments and memorials, large and small, and in the various furnishings dedicated to departed members of the noble families. The red-brick vestry on the north side of the chancel was built over a newly rediscovered Bacon family vault dating back to the early 1600s. In it are lead-lined coffins of eleven adults and four children. Among these is Sir John Holt who was Lord Chief Justice and who is commemorated by

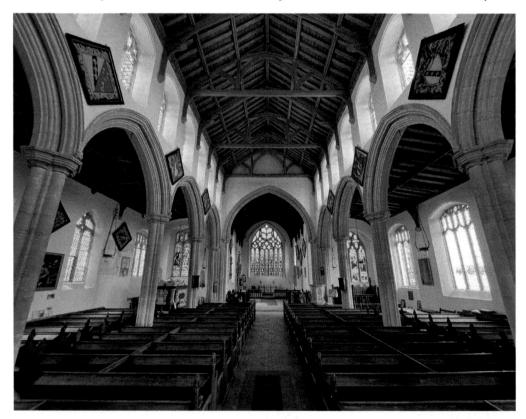

Redgrave. St Mary's has more funerary hatchments than any other church in Suffolk. (Photo by Sarah Doig)

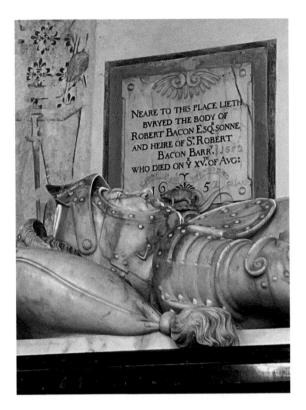

Redgrave. Sir Nicholas Bacon's effigy atop his large, marble tomb with a medieval wall painting behind. (Photo by Sarah Doig)

the extremely large, early eighteenth-century marble monument in the chancel. He is depicted in his judicial robes with figures of Justice and Mercy on either side.

Of the other memorials dotted around St Mary's, by far the finest is in the east end of the north aisle and is the table tomb of Sir Nicholas Bacon and his wife, Anne, with white marble effigies of both. These were designed by the celebrated sculptor Nicholas Stone who also designed the Bacon chapel at the west end of the same aisle where various wall and floor monuments to that noble family can be found.

In 2019, the six bells in St Mary's were rededicated by the Bishop of St Edmundsbury and Ipswich. The timberwork of the bell-frame was refurbished, refitted or replaced and the bells, dating from 1736 and 1785, were removed and retuned. This work was made possible following a legacy of £142,000 by Albert Driver, who had rung the bells in Redgrave for eighty years.

43. STOWLANGTOFT, ST GEORGE

This church is an unexpected favourite of mine. I first visited in the early summer when the churchyard grass was at its lushest and the sky its bluest, and the sun striking the elegant stonework made me instantly fall in love with St George's. Perhaps the reason why I particularly like it is the fact that the church is almost entirely the work of just one building phase – between around 1370 to 1420 – and it therefore has a pleasing coherence. It is an elegant and graceful structure with chequerboard flushwork around the tops and bases of the walls, as well as on the well-proportioned buttresses and on the front face of the porch. The west and

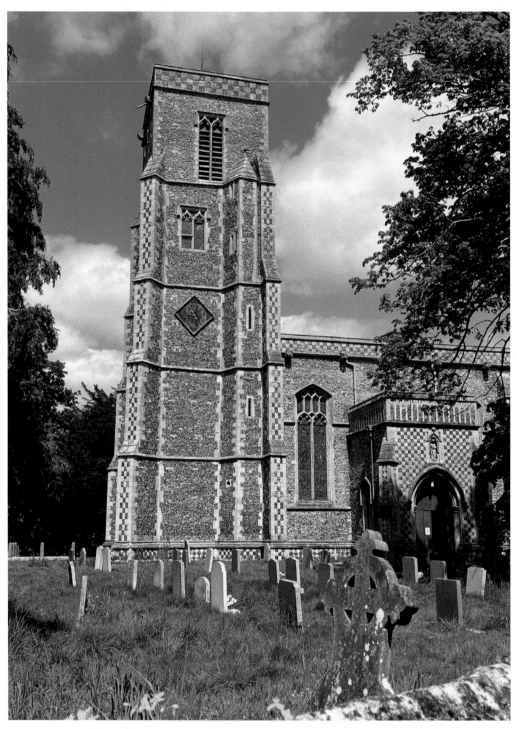

Stowlangtoft. Chequerboard flushwork on the tower buttresses and around the top and base make for a very attractive church. (Photo by Sarah Doig)

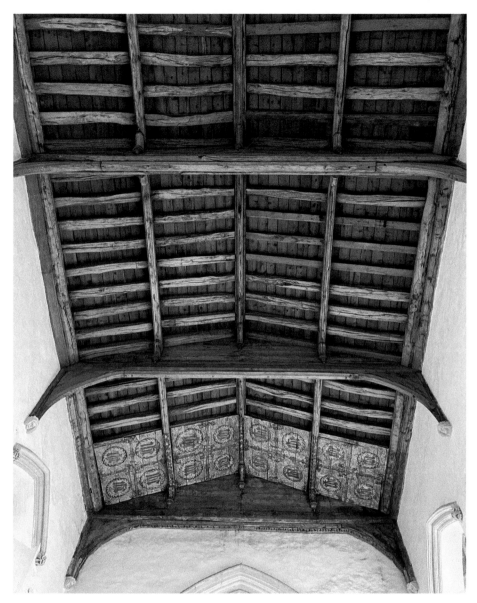

Stowlangtoft. Money was left in a 1520 will for the painting of the ceiling portion about the rood screen. (Photo by Sarah Doig)

south doors are both probably the original medieval woodwork, as is the staircase door inside the tower.

The sense of height and space continues inside with lofty tower and chancel arches. The nave roof incorporates much of its fifteenth-century timber and the base of the original rood screen is still in place and, although the painting on the panels is later, the framework has its original colour. There is also a host of other original features including the enormous wall painting of St Christopher which,

albeit now rather faded, must have had a real impact on those entering St George's from the main door opposite. Another original gem here is the set of beautifully carved poppyhead benches. They have been expertly restored and it is therefore easy to make out all manner of man and beast, including a cockatrice (a serpent with a bird's head), a fox with a goose in its mouth, a wild boar playing a harp and a cockerel. In the chancel are some equally well-preserved stalls with traceried end panels and wonderful carvings of people at the top, such as priests in a pulpit and at prayer. There are six misericord seats with human faces on the armrests. On the underside of the seats are various animals including a dragon and a lion.

St George's was fortunate to have a Victorian rector who was a supporter of the Oxford Movement which championed the restoration of churches along pre-Reformation lines. So, although much renewal, as well as the refurnishing, was undertaken in the nineteenth century, including the altar, reredos and much of the stained glass, it is in keeping with the original building.

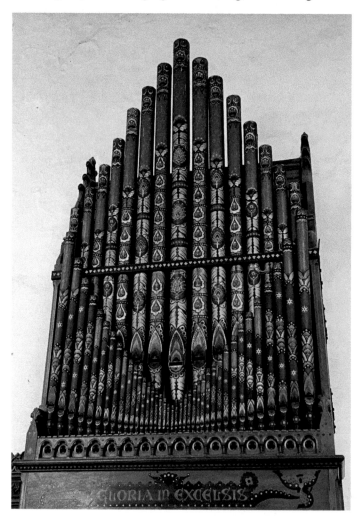

Stowlangtoft. The Victorian chancel organ is almost identical to one shown at the International Exhibition of 1862. (Photo by Sarah Doig)

44. THORNHAM PARVA, ST MARY

St Mary's, Thornham Parva is, in my opinion, perfectly formed. Its churchyard is possibly the most tranquil spot I have ever had the fortune to find. There is something quite special about the timeless beauty of the church and its surroundings. As I sit on the bench outside, I am in good company. There is the seemingly ever-present cock pheasant, as well as the graves of the celebrated architect of Coventry Cathedral, Sir Basil Spence, and his wife. Spence lived in nearby Yaxley Hall, and I wonder whether he too sat where I now sit, drawing inspiration from this setting.

There are traces of Saxon building in the walls, which were mainly built in the twelfth century. Both south and north doors are Norman too with the smaller priest's door in the chancel having been constructed slightly later. Apart from one remaining Norman one, the windows date from the 1400s. The tower was rebuilt in the 1480s and is, unusually, thatched in Norfolk reed like the rest of the church.

St Mary's is home to many treasures, packed tightly into a tiny church, although the visitor's eye is always first drawn to the amazing set of wall paintings dating back to the fourteenth century. They were rediscovered in the 1920s and conserved some seventy years later. The paintings on the north wall depict the story of St Edmund, and the north door has been used as a bridge for the martyred king's cart. On the south side are paintings showing the birth and early years of Christ.

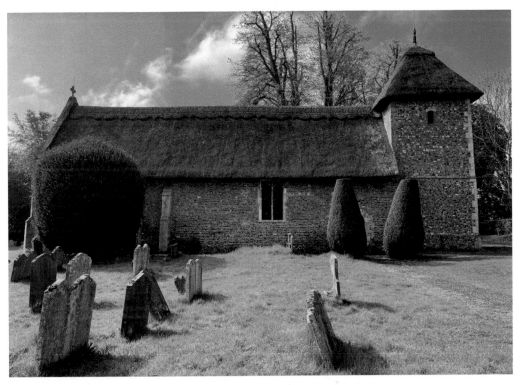

Thornham Parva. I have spent many contented hours sitting on the bench looking at this view. (Photo by Sarah Doig)

Thornham Parva. A delicate
etched window in memory of
Osla (d. 1974), wife of Sir John
Henniker-Major. (Photo by
Sarah Doig)

The priceless oak panel painting (or retable) is what draws most people to Thornham Parva. It is considered to be one of the greatest treasures of medieval art in Europe. This and another companion piece now in a Paris museum were once part of a larger work which was painted for the Dominican order of monks at Thetford Priory in Norfolk, and may then have been kept in a private chapel after having been saved from destruction during the Dissolution. The retable was discovered in 1927 in an outbuilding on the Thornham Hall estate and the landowner, Lord Henniker, donated the work of art to Thornham Parva church where his brother was the rector. In 1994 the artwork was moved to the Hamilton Kerr Institute at the University of Cambridge's Fitzwilliam Museum where it underwent seven years of painstaking conservation before being restored to its place behind the altar in the church.

45. UFFORD, ST MARY OF THE ASSUMPTION

'There is a glorious cover over the font, like a pope's triple crown, with a pelican at the top, picking her breast, all gilt over with gold.' So recorded the iconoclast, William Dowsing, on his second visit to Ufford in August 1644. Seven months earlier, Dowsing and his men had destroyed some forty angels in the roof, as well as removed the stained glass in numerous windows and taken up brass monumental inscriptions. It is therefore a miracle that St Mary's magnificent font cover was never destroyed; how fortunate we are to be able to marvel, today,

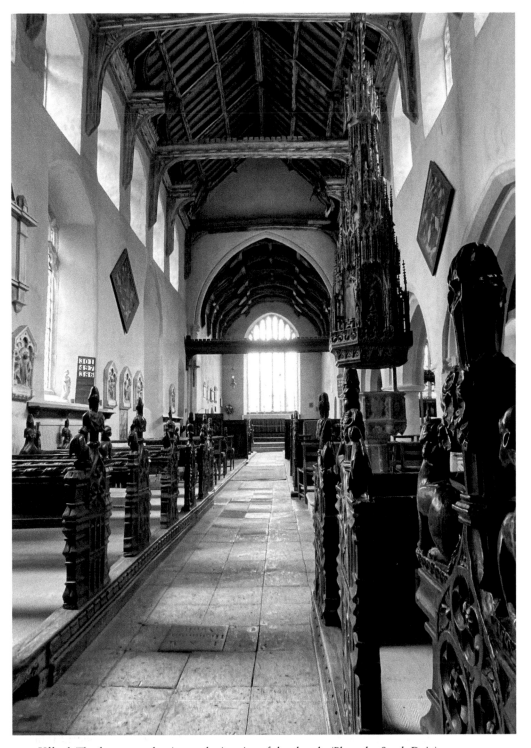

Ufford. The font cover dominates the interior of the church. (Photo by Sarah Doig)

at what the church historian H. Munro Cautley described as 'the most beautiful in the world'. Aside from its glorious decoration and recently restored colour, the cover is a masterpiece of medieval engineering. The 5.5-metre structure was designed in two tiers so that the lower part can be hoisted upwards to slide over the upper tier, thus revealing the holy water in the font. The cover dates from around 1450, the same date as the font itself which also still bears traces of the vivid colours in which it was once painted.

The angels in the nave roof destroyed by the Puritans have been replaced by some carved in the 1890s at Oberammergau, the Bavarian town once renowned for its skilled woodcarvers but now more famous for its ten-yearly passion play. The tie beams and the chancel roof still retain some original colouring and gilding, as does the surviving lower section of the fifteenth-century rood screen.

St Leonard's Chapel, at the east end of the south aisle, is now a memorial to commemorate the First World War. It was designed by Sir Ninian Comper, one of the last great Gothic Revival architects, who also designed the reredos and the unusual stained-glass window. It depicts Jesus carrying his cross, helped by a British soldier and sailor.

46. WALPOLE, OLD CHAPEL

Were it not for the gravestones dotted around the grass, it would be easy to think you were admiring a handsome, well-preserved sixteenth-century farmhouse, which of course you are. However, this building has served a very different purpose for the past 300 years or so.

Suffolk has a long history of religious dissent, stretching back to the late fourteenth century. But after around 1600, nonconformity grew rapidly. The seventeenth century saw several periods during which nonconformists were persecuted for their faith but in 1672, Charles II allowed the official licensing of nonconformist ministers and places of worship (usually private houses). We know, therefore, that there were at least ninety-eight towns and villages in Suffolk which contained nonconformist congregations at that time including at Halesworth. Final recognition of religious dissenters came in 1689 with the Toleration Act under William and Mary. This is when many purpose-built chapels were erected by various denominations.

On 19 August 1689, Halesworth's Independent congregation was granted the lease of a farmhouse in the nearby village of Walpole at an annual rent of ten shillings. This farmhouse was transformed into a dramatically large, full-height room by removing the ceiling and widening the roof span. A gallery was built on three sides of the building so that the congregation was able to fix their eyes on the hexagonal canopied pulpit from which the minister read from the Bible and preached its lessons. The tall, arched windows on either side of this pulpit served to lend as much light as possible on the Word of God. Today the chapel is now formally closed, having continued as a regular place of worship through to 1970. It is now maintained by a national body called the Historic Chapels Trust and is used for the occasional service and for concerts.

Above: Walpole, Old Chapel.
A simple exterior. (Photo by
Sarah Doig)

Right: Walpole, Old Chapel.
A simple interior. (Photo by
Sarah Doig)

47. WESTHALL, ST ANDREW

This is not a church you tend to happen across by accident but if you do, or like me set out to visit, you will be rewarded with a whole host of delights. Some of these will be staring you in the face and others take some searching to uncover.

St Andrew's unmissable star of the show is its Seven Sacrament font which, unlike other fine examples in Suffolk, still retains quite a lot of its original paint. It has, sadly, been badly mutilated either at the time of the Reformation or by the Puritans in the following century, but the scenes are still recognisable and with an octagonal font such as this, the eighth panel depicts the Baptism of Christ. Westhall's font is by no means the only splash of medieval colour. Separating the nave and chancel is the lower part of a rood screen and although the faces of the sixteen saints were defaced at some time in its history, some have been restored. The two parts of the screen appear to have been painted by two different artists and at different times, the panels attached to the south-facing wall being of far finer quality. One section of the north part is unique in that it is a triptych depicting the Transfiguration, with Christ on a mountaintop flanked by Moses and Elijah. Believe it or not, there is yet more medieval colour to be found, this time on the walls in the form of some of the uncovered wall paintings. These include a large

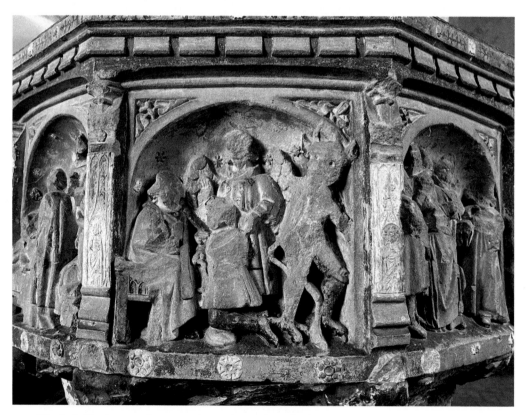

Westhall. The font panel representing Penance where the devil creeps away with his tail between his legs having led the penitent astray. (Photo by Sarah Doig)

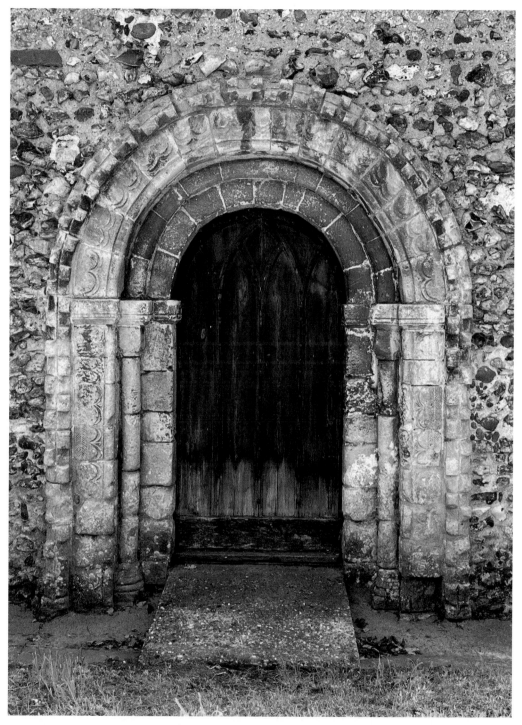

Westhall. It is always worth walking right around the outside of churches. This Norman doorway is hidden on the north side. (Photo by Sarah Doig)

St Christopher and a much smaller picture of Moses with horns protruding from his head: it seems that the original Hebrew description of the prophet wearing a halo was mistranslated in the Middle Ages as 'horns of light'!

You then must look a bit harder to discover the initial layout of St Andrew's. The original church was Norman and comprised a nave, a central tower and then a chancel with a rounded end. It was largely rebuilt and enlarged in the fourteenth century. The tower was moved to the west end of the twelfth-century nave which became an aisle when a new nave, porch and chancel were constructed to the north. How do we know this? Well, primarily because the ornate west façade of the original church, resplendent with comical Norman faces carved into the archway, was kept and incorporated into the new west tower.

48. WESTLEY, ST MARY

St Mary's, Westley is made of cement. Yes, you read that correctly: I said cement. In fact, it is one of the earliest churches in England to have been built using precast concrete blocks and I must admit, I quite like it! By 1934, the medieval church of St Thomas à Becket in Westley was in a very poor state of repair and much neglected. It was never used again and only a few ruins remain on the western end of the village. Enter then, the 1st Marquess of Bristol of Ickworth House who was

Westley. A concrete monstrosity or an elegant, quirky place of worship? (Photo by Sarah Doig)

using a builder from Brighton, William Ranger, to make alterations and additions to the house and to the church on the estate. Ranger had recently patented an artificial stone – a concrete composed of gravel, sand and lime mixed with boiling water – and invented precast concrete blocks. The Marquess of Bristol gave both the land in Westley on which to construct a brand-new church, as well as £600 towards the cost of the building works. So, William Ranger oversaw the construction of St Mary's which was made by pouring his cement between timber shuttering and by using his concrete blocks in the tower and the churchyard walls. The cement was then faced with a lime and sand plaster. The slate roof is supported by cast-iron hammerbeam trusses, another new building technique at the time.

It is said that the Marquess of Bristol chose this spot so that the church spire would be visible from his Ickworth estate. It was a spire with pinnacles and flying buttresses like that of St John's Church in nearby Bury St Edmunds. Sadly, the spire at Westley did not stand the test of time. It was affected by frost and damaged by lightning, causing some of the plaster to fall off, leading to the spire being declared unsafe. In 1961, it was replaced with the present pyramidical slate roof. The exterior walls have also weathered badly and required costly restoration in the late twentieth century.

The church interior is dark, plain and rather forbidding, a stark contrast to the bright, welcoming exterior.

49. WINGFIELD, ST ANDREW

Wingfield is all about one of England's most powerful families of the Middle Ages. It is their final resting place, founded by their forebear who also lies in the chancel. 'The church must be in great part built anew … and constructed on a larger scale than before … at very great expense.' So reads the charter for the foundation of St Andrew's following the death of Sir John de Wingfield in 1361 who left money for a college of priests to be established and for this collegiate church to be built adjacent to the college. Sir John had shrewdly married his daughter and heiress off to one of the up-and-coming families in the land, the de la Poles, and it was Sir John's son-in-law, Michael de la Pole, who was created 1st Earl of Suffolk by Richard II with whom he enjoyed a close friendship.

The chancel is therefore the focus of St Andrew's. It was where the choir of the college sang and where the college chaplains said their daily prayers, a few steps away from where their founder lay at rest in a grand tomb topped with a stone effigy of him. This was once brightly painted and was probably originally in his chantry chapel (now the vestry). The 2nd Earl of Suffolk and his wife are also buried in Wingfield's chancel, as is John de la Pole, the 2nd Duke of Suffolk, and his wife, Elizabeth Plantagenet, whose effigies are finely carved in alabaster. No expense was spared, either, for the priests and choir as their return stalls are works of great craftsmanship, incorporating misericords for the chaplains to rest their weary legs. The woodwork is raised from the chancel floor providing an acoustic chamber underneath to add resonance to the singing.

The whole church is light, thanks to the many clerestory windows. Although even here, many more have been built into the chancel than the nave, the latter

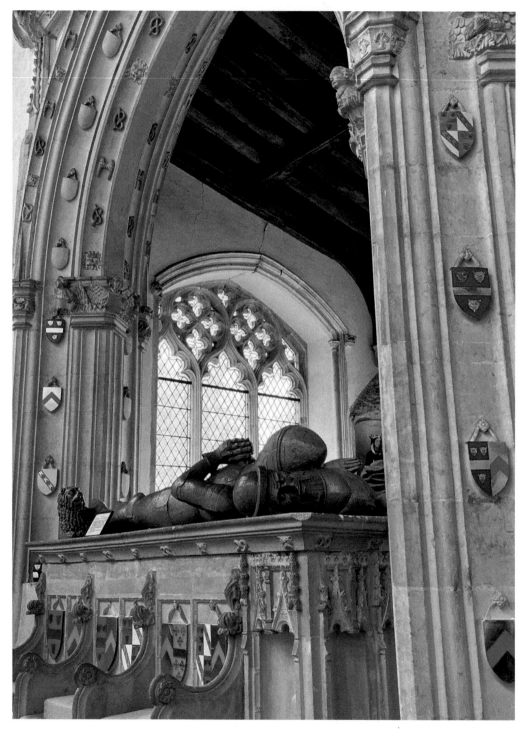

Wingfield. The wooden effigies of Michael de la Pole and his wife, Katherine, were once painted. (Photo by Sarah Doig)

Wingfield. Wingfield College is visible through the window by the south rood stairs. (Photo by Sarah Doig)

being a very poor relation with very little of real interest in it. Two elegant brick and stone staircases remain to the east of both north and south aisles, once leading to the rood loft. Even the early fifteenth-century font is, sadly, unexceptional compared with others in Suffolk.

50. WITHERSDALE, ST MARY MAGDALENE

St Mary Magdalene looks rather out of place in the Waveney valley. It is as if it, together with Dorothy and Toto, has been transported by a tornado not from Kansas but from Essex. I always expect to find the feet of the Wicked Witch of the East sticking out from underneath the porch! It is a dear little church, one of the smallest in the county and an absolute delight to visit. It is a simple, one-cell building of early Norman origins: the nave probably dates from the late eleventh century, the chancel is very early thirteenth century and the timber-framed south porch dates from the same period. There is no chancel arch, and, in fact, the chancel is slightly wider on the inside than the nave. A variety of windows dating

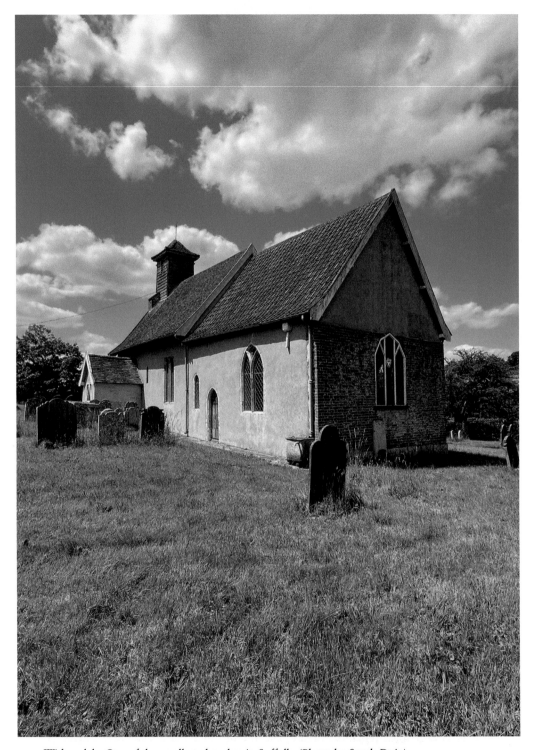

Withersdale. One of the smallest churches in Suffolk. (Photo by Sarah Doig)

Withersdale. The tastefully furnished interior viewed from the gallery. (Photo by Sarah Doig)

from the twelfth to the fifteenth century punctuate the north and south walls. The small weatherboarded belfry on the western gable once had a wooden spire but was removed in the last century.

The carefully restored and well-kept (and clearly well-loved) interior of St Mary Magdalene holds so many little gems from points in the church's long history, yet it remains uncluttered. The body of the church is best viewed from the seventeenth-century musician's gallery (mind yourself on the small, steep ladder!). From here you can appreciate the beauty and simplicity of the church. Many of the furnishings are Jacobean, including the communion rails, altar, and the benches and box pews in the nave which face towards the seventeenth-century double-decker pulpit. The pulpit retains its original back board and canopy which served to amplify the preacher's voice.

Having left the very best of this church to last, the font is tremendous, both in appearance and size. The square bowl, which now rests on a brick base, dates from around 1180 and has different carvings on all four sides, three of these probably contemporary with the font itself. The carvings range from arches and pillars, a human face, to some foliage which is thought to represent the Tree of Life.